Yosemite and the Range of Light

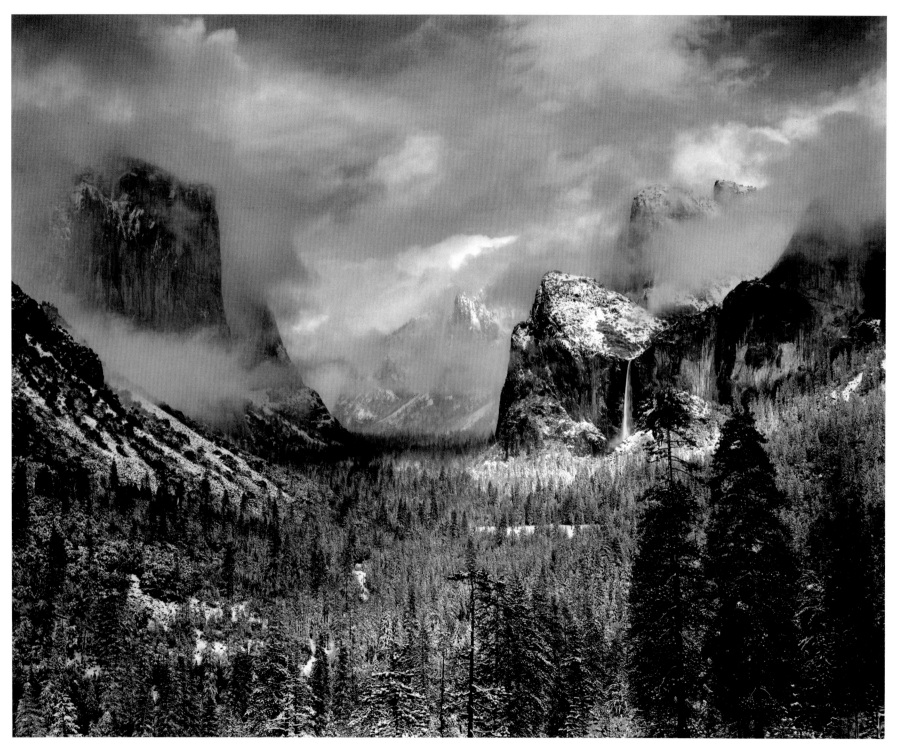

1. *Clearing Winter Storm, Yosemite Valley 1944*

ANSEL ADAMS

Yosemite and the Range of Light

INTRODUCTION BY PAUL BROOKS

A NEW YORK GRAPHIC SOCIETY BOOK

LITTLE, BROWN AND COMPANY · BOSTON

INTERNATIONAL STANDARD BOOK NUMBER: 0-8212-1523-X (REDUCED-FORMAT PAPERBACK)

LIBRARY OF CONGRESS CATALOGUE CARD NUMBER: 78-72074

NEW YORK GRAPHIC SOCIETY BOOKS ARE PUBLISHED BY LITTLE, BROWN AND COMPANY (INC.).

PUBLISHED SIMULTANEOUSLY IN CANADA BY LITTLE, BROWN AND COMPANY (CANADA) LIMITED.

PRINTED IN THE UNITED STATES OF AMERICA.

NINTH PRINTING, 1988.

For Virginia

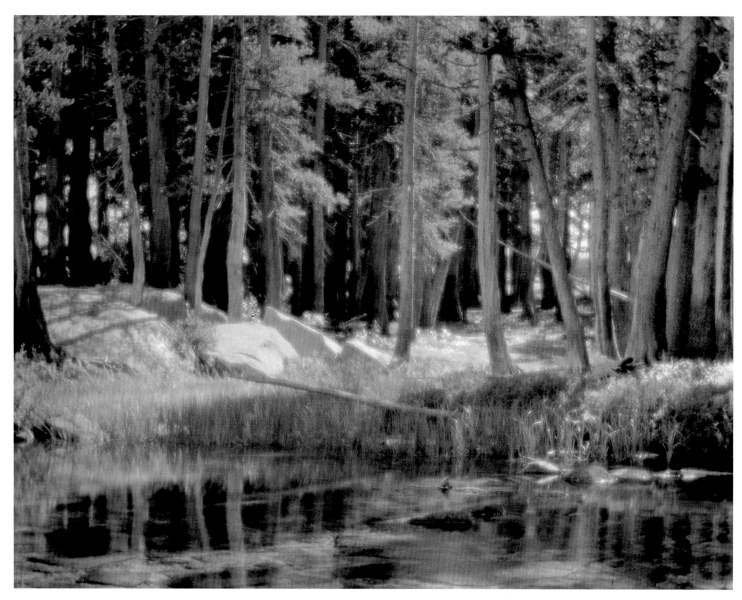

2. *Lodgepole Pines, Lyell Fork of the Merced River, Yosemite National Park 1921*

Foreword

SINCE JUNE 1916 the Sierra has dominated my mind, art and spirit. It is quite impossible to explain in words this almost symbiotic relationship. My photographs must serve as the equivalents of my experiences, and I hope they may help others to express their own experiences in whatever medium they choose. All art is a vision penetrating the illusions of reality, and photography is one form of this vision and revelation.

The Sierra Nevada, so aptly called the "Range of Light" by John Muir, rises as a great wave of stone for four hundred miles between the arid wastes of the Great Basin and the verdant Central Valley of California. In the billowing western slopes are many valleys and canyons, carved first by the forces of water and then configured by great rivers of ice during several glacial ages. The grinding ice moved from the summits down to elevations of two to four thousand feet. The geologic history of the Sierra is ancient and complex, and scientists are still pondering the uplifts, the faults and the patterns of erosion of this vast, tilted block of the earth's surface.

Those who have seen the great uplifts of the Himalayas, the Andes, the Alps and the Alaskan ranges may not think of the Sierra Nevada as *mountains*. They have neither formidable rivers of ice nor skies cut with forbidding towers of rock. I think of the Sierra as sculptures in stone, rather delicate and gentle, yet not small! The canyons reach seven thousand feet in depth, and the eastern face of the range rises more than ten thousand feet above the Owens Valley. The juxtaposition of rock, glacial lakes, meadows, forests and streams is extraordinary. It is the *detail* of the Sierra that captures the

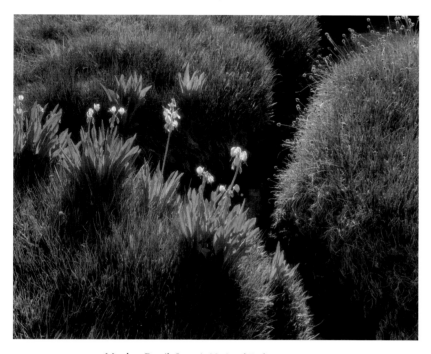

3. Meadow Detail, Sequoia National Park 1930

eye and entices the camera. One wanders in open forests and wild gardens of infinite variety studded by boulders of whitish granitic or lichened metamorphic. Spring follows the elevations from the low, rolling foothills; at eleven or twelve thousand feet September flowers will bloom in the crevices of the clean and shining summits. No mountain is so large that you cannot climb from its immediate base and descend in a day.

Spectacular thunderstorms of summer pile ten-mile-high white billows into the sky; thunder reverberates from the granite walls and basins with the metallic roar of great gongs. John Muir said it never rains in the Sierra at night, and it seldom does. At dawn the high meadows may be white with frost. There is a purity and clarity of air through which the stars seem very close, and the dawn wind makes the forests and crags coolly and gently vocal.

Yosemite Valley is a small but supremely impressive section of the Merced River complex. In the valley, the Merced represents the joining of many tributaries, flowing from sources in the highest summits, the cirques, glacial lakes and meadows of what we call the High Sierra of the Merced watershed. North of the Merced flows the Tuolumne River, larger in resource and power. South lies the largest river system, the San Joaquin. And farther south are even loftier source regions of the Kings, Kaweah, and Kern rivers — all flowing down to the Central Valley, and, in earlier times, all but the last-named streams to the bay of San Francisco and the Pacific Ocean. Irrigation and urban demands now leave little water to complete the journey to the sea. The waters of Lake Tahoe at the northern end of the Sierra Nevada flow down the Walker River to the eastern desert.

Turn to the many estimable books available on the natural sciences and history of the region if you wish to ponder the facts and grasp the realities. The function of this book is to present visual evidences of memories and mysteries at a personal level of experience. Most such experiences cannot be photographed directly but are distilled as a synthesis of total personal significance; perhaps their spirit is captured by images visualized through the obedient eye of the camera.

I came to Yosemite for the first time in 1916, at the age of fourteen, and for me it was a tremendous event. My first impressions were of monuments of great height, stately sculptures of stone glowing in searching sun, white waters pouring in thunder from the cliffs, and a sky active with clouds. The Merced was in full spring flood; rapids, deep pools, facades and grottos of forest, and light everywhere.

Through 1924 I explored almost every accessible feature of Yosemite Valley and the adjacent High Sierra. In 1925 and 1926 I made extensive trips into the Kings River Sierra with the Joseph Le Conte family. Then, in 1927, I made my first High Trip with the Sierra Club into the Kaweah and Kern Sierra. In 1929 and after, I made many trips with the Club, serving as assistant manager of their month-long outings, hiking and climbing with my cameras, helping set up the camps, organizing the mountaineering programs, managing the evening camp-fires and seeking lost people. The day usually ended loading plates or films in their holders using a photographic changing bag or lying head down in a stifling sleeping bag. This very hectic program was repeated for about five years with the Sierra Club. At other times I would explore many remote areas, including the east side of the Sierra, which dips to the desolate but beautiful Owens Valley, and I would also wander about the Alabama and Tungsten Hills, remnants of ancient Sierra ranges composed of a marvelous chaos of weathered granitic rocks. Every year since 1916 has found me in some part of the Sierra Nevada. It has truly been a life-

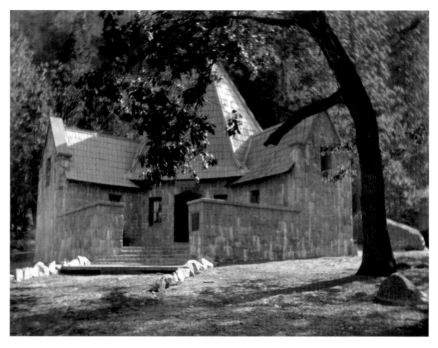

4. Le Conte Memorial, Yosemite Valley c.1920

time of close contact and great experiences with nature.

Since 1919, when I joined the Sierra Club, I was seriously involved with the conservation movement. From 1919 to 1924 I was summer custodian of the Sierra Club's Le Conte Memorial in Yosemite Valley. I passed through the messianic period, battling the implacable devourers and mutilators of wilderness, and gradually I entered a more philosophic–humanistic stage where I was able, in some small way, to separate personal euphoria from im-personal appraisals of the rights of man to participate in the bounties of his environment. The fact that he has

9

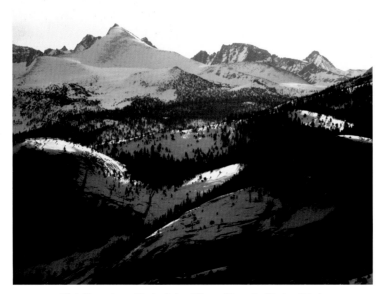

5. High Sierra from Glacier Point, Winter, Yosemite National Park c. 1925

The trails were mostly primitive, and the maps not too accurate. But all the streams and lakes were pure, the air was crystalline except when some distant forest fire put an amethyst veil over the mountains. I cooked over an open fire, my grate was a little Stonehenge of rocks on which blackened tin cans (with wires for grasping) teetered with sometimes disastrous results. A warped frying pan and a small bucket completed the regal equipment. Salt, bacon, tinned butter, flour, rice, coffee, dried or condensed canned milk, bars of chocolate, dried fruit and a can or two of Log Cabin syrup filled one kyack of my pack; the other was reserved for simple utensils, cameras, and film. An old-fashioned sleeping bag and a sheet of canvas were lashed across the top of the pack. I had no air mattress; such was considered effete. I would sleep on some gathered branches or pine needles, sometimes on bare glacial rock. In some way my body molded its way through a thin blanket to the contours of the stone, and I slept in blissful, comparative comfort.

It frightens me now to think of many of the ascents I made during those times. I had no idea of the techniques of climbing, but in some way I survived. My old friend Francis Holman and I made really hazardous scrambles tied together with a window-sash cord. We did not know the real meaning of a belay and often climbed in unison; if one had slipped and fallen, the other would inevitably have been dragged along to disaster. We would be drummed out of the mountaineering fraternity if we tried any such adventure now. Yet the advanced climbers of today, while they perform miracles of vertical virtuosity,

fouled his nest and seems certain to continue with his destruction seems now more of an illness than an expression of evil intent. The problem is not *whether* we must save the natural scene, but *how* we may accomplish it.

As I look back to earlier days, there were so few travelers in the Sierra that I began to feel a certain sense of "ownership"; they were *my* mountains and streams, and intruders were suspect. I got over that distortion of reality quite early, but I can still recall the wondrous experience of wandering for days completely alone (except, perhaps, for my donkey). There was only an occasional small vagrant plane in the sky; there were no radios or rescue helicopters, and no contrails lacing the dome of heaven.

may have created with their pitons and expansion-bolt drilling more damage to the cliffs than ten thousand years of natural erosion. Our early climbing experiences left no trace whatever. But the most dedicated and gentle human feet, if there are enough of them, will wear down the sternest stone, strangle the near-surface roots of the giant sequoias, and flatten meadows into hardened promenades. The preservation and, at the same time, the human use of wild places present a mind- and spirit-wracking challenge for the future.

I am an ardent believer in wilderness, which reflects the mystique of nature, and I have enjoyed both companionship and solitude in the high mountains. From the beginning I was impressed by the philosophy that all life and art are justified by communication; experiences are to share, not to hoard. In earlier days the Sierra Club Annual Outings brought hundreds of people a year into the Sierra to give them memorable experiences and to influence them to work for preservation of wild places. Ironically our citizens have responded with encouraging unanimity, and now overpowering numbers of wilderness worshipers come to the high altars and sacred groves.

William E. Colby, the great conservationist and leader of the Sierra Club, told me that around 1910 when he and John Muir were at Glacier Point above Yosemite Valley Muir said, "Bill, won't it be wonderful when a million people can see what we are seeing now!" Many millions have experienced this noble view since 1910; the great domes and distant summit peaks have not visibly changed, and, as Edward Carpenter wrote, the forests

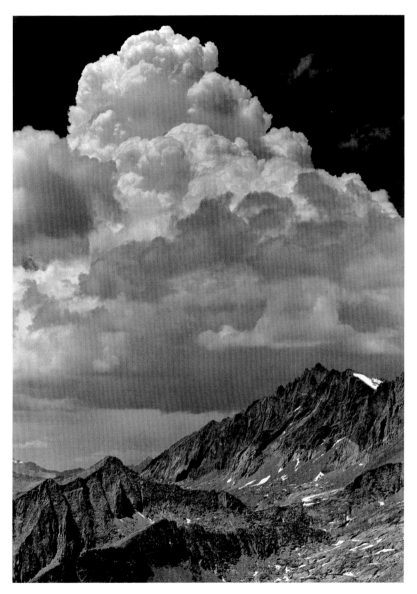

6. Thundercloud, North Palisade, Kings Canyon National Park 1933

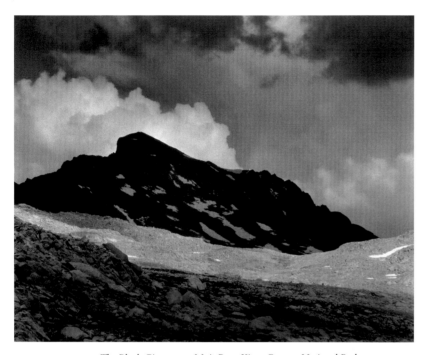

7. The Black Giant, near Muir Pass, Kings Canyon National Park 1930

continue to flow over the land as cloud shadows. No evidence of man can be seen, except on the floor of Yosemite Valley, and this promises to be reduced within practical limits in the coming years. Establishment of the Parks and Wilderness Areas has secured the integrity of vast domains of natural beauty. I hope that those entrusted with the administration of these areas will ever be alert to the constant and increasing pressures for many forms of exploitation. The problem is one of balance between highly restrictive preservation and the concept of appropriate use.

I knew little of these basic problems when I first made snapshots in and around Yosemite. I was casually making a *visual diary*—recording where I had been and what I had seen—and becoming intimate with the spirit of wild places. Gradually my photographs began to mean something in themselves; they became records of experiences as well as of places. People responded to them, and my interest in the creative potential of photography grew apace. My piano suffered a serious rival. Family and friends would take me aside and say, "Do not give up your music; the camera cannot express the human soul." My soul was on trial during the years around 1930. I tried to keep both arts alive, but the camera won. I found that while the camera does not express the soul, perhaps a photograph can! My relatively incoherent and romantic philosophy was clarified and strengthened by meeting Paul Strand in Taos in 1930 and Alfred Stieglitz in New York in 1933. Stieglitz's doctrine of the equivalent as an explanation of creative photography opened the world for me. In showing a photograph he implied, "Here is the equivalent of what I saw and felt." That is all I can ever say in words about my photographs; they must stand or fall, as objects of beauty and communication, on the silent evidence of their equivalence. Later my lifelong association with Beaumont and Nancy Newhall introduced me to the world of museums, exhibitions, and books. These people were among the few I knew who stood unflinchingly for quality and integrity in the arts.

When I reviewed for this book the thousands of photo-

graphs that I have made in Yosemite and the Sierra Nevada since 1916, more than 60 years telescoped into a vast exhibit, a unified tapestry of experience. The photographs recreate, for me, moods, realities, and magical experiences, and they have been selected for these reasons, not for their physical description of the great western range. I have considered Yosemite and the Sierra Nevada as an entity, and the pictures flow with their own energy and inner relationships. The images in this book are not in chronological order, nor are they collations of specific areas. I have never invaded the privacy of wildlife with my camera and have paid little attention to the formal identification of flowers, trees, and other natural phenomena. Animal life, including man, is conspicuously absent in this collection. To the complaint "There are no people in these photographs," I respond, "There are always *two* people; the photographer and the viewer."

The years are jumbled and I cannot remember dates. But my recall of place and experience is precise. Seeing these photographs together brought back the exhilaration of my youth, striding the high places with a heavy camera, absorbing the beauty of both lichen and distant peak, the sound of wind and water, and the ever-present benediction of light. Nor can I forget the hundreds of friends and companions encountered through those years; it is hard to imagine what life would have been without them.

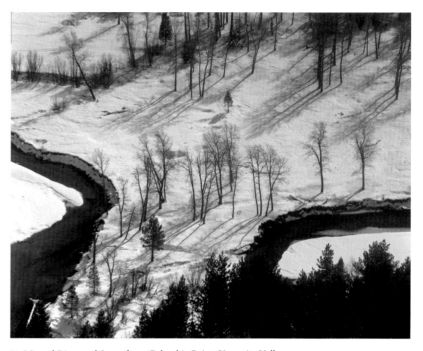

8. Merced River and Snow from Columbia Point, Yosemite Valley c.1923

I am glad that the artist can move through the wilderness taking nothing away from its inexhaustible spirit and bringing his vision-modulated fragments to all who come to see.

Ansel Adams
Carmel, California
January 1979

Yosemite: The Seeing Eye and the Written Word

BY PAUL BROOKS

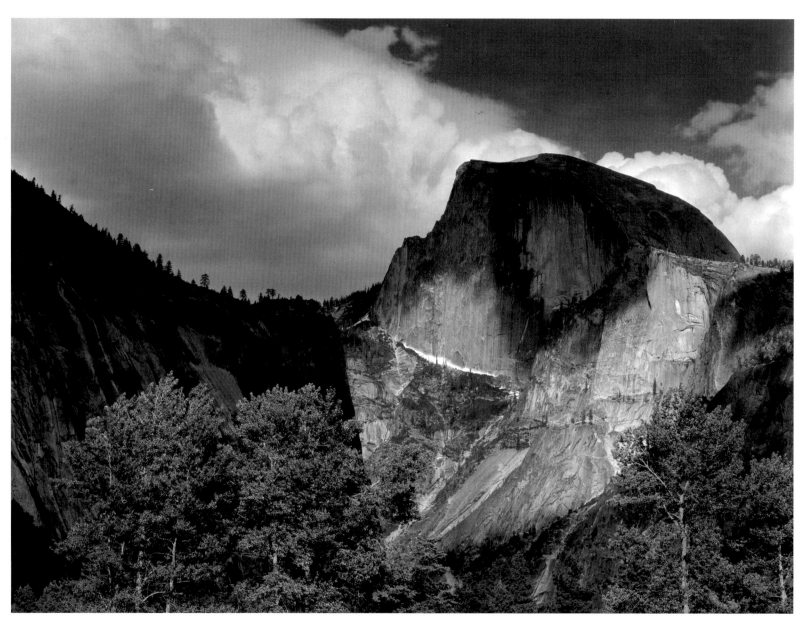

9. *Half Dome, Yosemite Valley c.1935*

In 1864, the year in which Yosemite Valley and the Mariposa redwoods were granted to the state of California for "public use, resort and recreation," a Vermont scholar named George Perkins Marsh published a book entitled *Man and Nature*. In it he wrote: "To the natural philosopher, the descriptive poet, the painter, and the sculptor [today he would have added "the photographer"], as well as to the common observer, the power most important to cultivate, and, at the same time, hardest to acquire, is that of seeing what is before him. Sight is a faculty; seeing, an art." Henry David Thoreau, himself no common observer, had already made a similar comment in his journal: "The question is not what you look at, but what you see."

Yosemite and the Range of Light, like every book by Ansel Adams, is a classic example of the art of seeing.

Thoreau of course never saw the Sierra, the "Range of Light," as John Muir called it. His well-trained eye roved only as far as the country within reach of Concord. Yet "every sunset which I witness inspires me with the desire to go to a West as distant and as fair as that into which the sun goes down." To most easterners of the mid-nineteenth century, the land beyond the Mississippi was still *terra incognita*. Exploitation of its resources had begun with the defeat of Mexico and the gold rush that followed in 1849, but aesthetic appreciation of its natural wonders was still confined to a few explorers and the artists who accompanied them into the heart of the continent. For the average frontiersman, wilderness was an enemy to be conquered. The long range of the Sierra, with its precipitous eastern escarpment, was seen principally as a barrier to the riches that lay beyond.

Today, when we treasure these mountains for their own sake, we look back with gratitude to those who first took joy in them, and whose eloquent words did so much to save them for the future—writers like Starr King,

Clarence King, Frederick Law Olmsted, John Muir. To put their achievements in perspective we must recall how relatively recent, in the long history of Western civilization, is the concept that wild mountain scenery can be a source of beauty and inspiration to mankind.

From earliest times, untamed wilderness had been considered wasteland, if not positively hostile. The Greeks, with their pantheon of nature gods, nevertheless found their chief delight in the gentle face of nature, in the pastoral scene. "Every Homeric landscape intended to be beautiful," wrote Ruskin, "is composed of a fountain, a meadow, and a shady grove. . . . Homer, living in mountainous and rocky countries, dwells delightedly on all the flat bits." So with the Romans. Horace sings the praises of his Sabine farm, but not of the mountains or the forest, which—in the succeeding centuries—became for the Christian world symbols of the sinful and the unholy. With the coming of the Renaissance these attitudes began to change; there was a new concern for the beauties of this world as well as those of the next. In the words of Havelock Ellis, "it embraced elements of the love of the wild, and these were notably shown in a new and actively adventurous love of mountains." The great change, however, was brought about by the so-called Romantic Movement of the late eighteenth century, heralded in France by Jean Jacques Rousseau and in England by the "Lake Poets." No longer was beauty to be found only in a tamed and ordered landscape; no longer could a poet like Andrew Marvell call mountains "ill-designed excrescences" or a famous writer like Madame de Staël

feel obliged to draw the curtains of her carriage when she passed through the Alps. By the end of the century, Wordsworth was celebrating the rugged beauty of the English Lake Country. Shelley gazed with awe, not with repulsion, at the serene grandeur of Mont Blanc: "—I look on high; / Has some unknown omnipotence upfurled / The veil of life and death? . . ." So might he have written of the Sierra: "Its subject mountains their unearthly forms / Pile around it, ice and rock; broad vales between / Of frozen floods, unfathomable deeps, / Blue as the overhanging heaven. . . ."

In America, Ralph Waldo Emerson's first book, *Nature*, opened the way to an aesthetic and even a religious delight in natural scenery. In contrast to the early churchmen, who castigated themselves for enjoying the fleeting beauties of a sinful world, ministers were not ashamed to seek inspiration in the hills. Emerson himself, as a young man, had sought the solitude of the White Mountains as he wrestled with his religious convictions; here, he knew, "the pinions of thought should be strong." These same mountains would be linked, through a unique chain of circumstances, with a fellow New Englander's discovery of the wonders of Yosemite Valley, and the wave of interest that resulted from his reports back home.

In 1860 a popular young preacher in Boston named Thomas Starr King, a friend of Emerson and the literary establishment, accepted a call to the new and struggling Unitarian Church in San Francisco—determined, as he put it, "to go out into the cold and see if I am good for

anything." A lover of nature since boyhood, he had just published *The White Hills*, one of the first and finest appreciations of the mountains of New Hampshire. Now he would have a chance to explore the grander ranges of the West, and particularly the marvels said to exist in the valley of the Merced River called "Yo Semite" (the Indian name for grizzly bear, applied to the local tribe because of its ferocity). In July of that first summer in the West, King took a brief leave from his pulpit and with four companions set out for the valley of which he had heard such provocative reports.

By this time it was fairly well known. Fur trappers had seen it as early as the 1830s, but the first detailed description had been written by a young volunteer in the state militia named Lafayette Bunnell, on a punitive expedition in 1851 against the Indians who were harassing the prospectors in the foothills. In his *Discovery of Yosemite*, Bunnell recorded his initial impressions with unmilitary sensitivity: "The grandeur of the scene was softened by the haze that hung over the valley—light as gossamer—and by the clouds which partially dimmed the higher cliffs and mountains. This obscurity of vision but increased the awe with which I beheld it, and as I looked, a peculiar exalted sensation seemed to fill my whole being, and I found my eyes in tears with emotion."

Four years after Bunnell, the first group of sightseers entered the valley. Their leader, James Mason Hutchings, publicized it in his *California Magazine*, and a California artist, Thomas A. Ayers, made sketches that were reproduced and sold in the East. A primitive hotel had been erected shortly before King arrived. Horace Greeley had paused briefly in Yosemite on his way west, and described it in articles for the *New York Tribune*.

Starr King—as he was generally known—had in mind something different and far more ambitious: a series of long letters to the *Boston Evening Transcript*, similar to those he had written on the White Mountains but devoted solely to the Yosemite trip. His narrative starts out at a leisurely pace, informal and chatty, but when he gets among the towering sugar pines and the gigantic redwoods as he looks up at Yosemite Falls and El Capitan, he is overwhelmed. Scraps of poetry and classical allusions mingle with awesome statistics, as he endeavors to evoke scenes scarcely imaginable to eastern eyes. Remembering his Boston readers, he describes trees "in whose trunk Bunker Hill monument could have been inserted and hidden, while the stem would still spring more than two hundred feet above its apex-stone." After giving us guidebook measurements of Yosemite Falls, he paints a word-picture as best he can, aware that "there has been a deal of mighty rhetoric born in California from the Yo-Semite and its wonders."

"It is the upper and highest cataract that is most wonderful to the eye, as well as most musical. The cliff is so sheer that there is no break in the body of the water during the whole of its descent of more than a quarter of a mile. It pours in a curve from the summit, fifteen hundred feet, (the height of six Park Street spires, remember,) to the basin that hoards it but a moment for the cascades that follow. And what endless complexities and opulence

of beauty in the forms and motions of the cataract! It is comparatively narrow at the top of the precipice . . . but it widens as it descends, and curves a little on one side as it widens, so that it shapes itself, before it reaches its first bowl of granite, into the figure of the comet that glowed on our sky two years ago." And so on.

Back in New England the *Transcript* articles, published in late 1860 and early 1861, made a great stir, and brought letters of congratulation from both Oliver Wendell Holmes and John Greenleaf Whittier. King hoped some day to write a book on the Sierras, a companion volume to *The White Hills*. Meanwhile, as a well-known writer and a prominent citizen of California, he could exert his influence toward preservation of the valley.

Alas, he did not live to see his hope fulfilled. He had been overworked almost from the day he reached San Francisco. An eloquent orator and passionate opponent of slavery, he had become a local hero for his tireless efforts in saving California for the Union. Early in 1864 he died of a sudden illness, brought on by exhaustion. Appropriately, a statue by Boston's Daniel Chester French was erected in San Francisco's Golden Gate Park. Peaks were named for him in the White Mountains and the Sierra.

King was no great writer, but as John A. Hussey remarks in his introduction to a volume of the *Transcript* letters, "his narrative marked a milestone in Yosemite literature because of his ability to make others visualize the scenes described and because of his already established reputation as a nature writer. If the naturalists who interpret our nation's great scenic parks have learned anything from years of dealing with the public, it is that there are many persons who must be told that a view is beautiful before they will be impressed." "No one had really seen the Sierra Nevada, Mt. Shasta, or the Yo Semite Valley," wrote his friend Henry W. Bellows, "until his fine eye saw and his cunning brain and hand depicted them." On June 25, 1864, only a few months after Starr King's death, Abraham Lincoln signed the bill that granted Yosemite Valley to the state of California, to be preserved "for all time." It was the first such act in our history.

For at least three reasons, the name of King will always be associated with the Sierra Nevada. Starr King is one. Another is the Kings River, from the Spanish *el Rio de los Santos Reyes*, the River of the Holy Kings. But for historians of the West, the magic name is that of a geologist, mountaineer, and writer whom Henry Adams considered to be "the most remarkable man of our time": Clarence King.

Born in Newport, Rhode Island, in 1842, eighteen years after his Boston namesake (they were not related), Clarence King, while still a schoolboy, acquired a passionate interest in the out-of-doors, in plants and rocks and fossils. At Yale he studied under James Dwight Dana, author of the *Manual of Geology*; he read John Tyndall's great work on the Alpine glaciers and went up to Cambridge to attend lectures by the famous Louis Agassiz. And in the midst of this torrent of new scientific thought he discovered, with a joyful sense of recognition, the

writings of an English aesthete in love with the past, John Ruskin. "To follow a chapter of Ruskin's by one of Tyndall's," he wrote later, "is to bridge forty centuries and realize the full contrast of archaic and modern thought." King had the rare gift of uniting the two. Scientifically trained, he would become a superb field geologist, an expert of mapping the mountains, a wizard in interpreting the story of the rocks. Yet at the same time he saw nature, as Ruskin did, with a poet's and a painter's eye; he "fitted into the ways of thinking of artists," as John LaFarge would later put it.

Clarence King's initial acquaintance with mountains had been largely through books. He had done some local geologizing, but the more he read, the more his thoughts turned to the West. Unlike Henry Thoreau, he was in a position to give substance to his dreams. During his last year at Yale, he had read with intense excitement a letter from Professor William H. Brewer of the California Geological Survey describing an ascent of Mount Shasta. This was enough to set him off. In the spring of 1863, a few months after his twenty-first birthday, King and two young companions started out on an adventurous journey by rail and mule train and horseback to California, equipped with letters of introduction to the men in the field. In San Francisco they met Brewer and Josiah Dwight Whitney, head of the survey—for whom the highest mountain south of Alaska would one day be named. With Brewer, King climbed Lassen's Peak in northern California. His biographer, Thurman Wilkins, describes the scene. "A raw wind howled across the mountain during their first ascent, on September 26th. King reached the topmost shaft, only to be blown back by the gale. Clouds obscured the landscape below, defeating the purpose of the climb. But Mount Shasta, seventy-five miles away, loomed from the mists, sharp and majestic—the peak which had drawn King like a magnet. He shouted to Brewer above the wailing of the wind: 'What would Ruskin have said if he had seen *this!*'"

If Clarence King had any doubts about his calling, that day dispelled them. The following spring found him again with Brewer, engaged in the first of a series of expeditions charged with the Herculean task of surveying the high Sierra and so filling in a vast blank area on the map of California. And after a summer of strenuous climbing, he made a final trip to survey the borders of the state park in Yosemite Valley. From these youthful adventures he drew the material for his *Mountaineering in the Sierra Nevada*, which remains a classic account of man's reaction to nature. Dedicated to Professor Whitney and the Geological Survey, it appeared in 1872, the same year as Mark Twain's *Roughing It*. The publication of these two books, in the words of Wallace Stegner, "represents the high-water mark of frontier literature that belongs properly to belles-lettres."

King once referred to *Mountaineering* as "a slight book of travel," but this was doubtless a graceful show of modesty. It is more than an account of high adventure. It is a work of literature, written with grace and humor, full of glowing descriptions of wild nature and mountain scenery. Reviewing *Mountaineering*, William Dean How-

ells wrote: "The light, the color, the vastness of that sky and earth, which seem another sky and earth from ours, have transferred themselves to Mr. King's page with a freshness and force that give us a new sense of the value of descriptive writing."

Mountaineering is the work of a romantic, courageous, and self-confident young man for whom the apparently impossible was merely a welcome challenge. Granted that he was given to exaggeration, and willing to embroider a bit to make a good story, the account of his daredevil climbs, such as the ascent of the peak he christened Mount Tyndall, are vivid enough to give the reader vertigo, and bearable only because one knows the writer lived to describe them. Yet beyond the thrill of the adventure itself one senses an almost mystical exaltation. As he struggles along the ridge below Mount Tyndall he looks up at "cliff above cliff, precipice piled upon precipice . . . culminating in a noble pile of Gothic-finished granite and enamel-like snow. How grand and inviting looked its white form, its untrodden, unknown crest, so high and pure in the clear strong blue! I looked at it as one contemplating the purpose of his life; and for just one moment I would have rather liked to dodge that purpose, or to have waited, or have found some excellent reason why I might not go; but all this quickly vanished, leaving a cheerful resolve to go ahead."

When at last they reached the summit, King, for all his joy in wild nature, was overwhelmed by the stark, cold grandeur of a world where there seemed no place for man. "Silence and desolation are the themes which nature has wrought out under this eternally serious sky. . . . I have never seen Nature when she seemed so little 'Mother Nature' as in this place of rocks and snow, echoes and emptiness."

Like other mountaineers before him, he found contact with the human world in the natural architecture of the rocks. "As I sat on Mount Tyndall, the whole mountains shaped themselves like the ruins of cathedrals,—sharp roof-ridges, pinnacled and statued; buttresses more spired and ornamented than Milan's; receding doorways with pointed arches carved into blank facades of granite, doors never to be opened, innumerable jutting points with here and there a single cruciform peak, its frozen roof and granite spires so strikingly Gothic I cannot doubt that the Alps furnished the models for early cathedrals of that order."

In page after page of *Mountaineering* one senses the contrast—if not the actual conflict—between the scientist's and the artist's view of the universe. Of a later expedition King wrote: "I was delighted to ride thus alone, and expose myself, as one uncovers a sensitized photographic plate, to be influenced. . . . No tongue can tell the relief to simply withdraw scientific observation, and let Nature impress you in the dear old way with all her mystery and glory, with those vague indescribable emotions which tremble between wonder and sympathy."

Clarence King's adventures in the High Sierra were but the prelude to a precocious scientific and administrative career. But like other brilliant persons before and since, he apparently spoke even better than he wrote, talking

away the books he might have written. With his wit, his charm, his zest for life, he became a sort of romantic hero to the intellectuals of his time, until a nervous breakdown cut short his career. For Henry Adams he was always "young and bloomful. . . . He remained the best companion in the world to the end."

When Clarence King, in the autumn of 1864, had undertaken to survey the boundaries of the Yosemite reserve, he did not know that the man who gave him the assignment would have a unique influence in shaping the American landscape. Frederick Law Olmsted, Chairman of the first Board of Yosemite Valley Commissioners, was a forty-two-year-old New Englander, a pioneer in the new profession of "landscape architecture." The previous year, owing to a disagreement with the city authorities, he had interrupted the monumental task of creating Central Park in New York to take over the management of the Mariposa Estate, General Frémont's huge gold-mining property in the western foothills of the Sierra—the same property that King had been studying for the Geological Survey. Thus, through a happy accident of geography, Olmsted had come to know the Yosemite country at the precise moment in history when his leadership was most needed to ensure its preservation.

Olmsted was a complex character: a man with the imagination and sensitivity of an artist and the iron will of an executive; an idealist, a perfectionist with a driving social conscience who nevertheless remained uncertain for many years about the choice of a career. Born in Hartford in 1822, he came of Puritan stock, dating back to the early days of the Bay Colony and the founding of Connecticut. His forebears were simple people: seafarers, farmers. Fortunately his father had an innate love of nature which expressed itself in family excursions through the Connecticut River Valley, the White Mountains and along the coast of Maine; to Lake George and the Hudson; to Quebec and Niagara Falls. These vacation trips sharpened young Olmsted's powers of observation and gave him a feeling for natural scenery.

In his first book, describing a walking trip in England, Olmsted made the distinction between two equally valid approaches to the appreciation of nature: the joy in pure wildness on the one hand and, on the other, the age-old love of the pastoral scene. "The sublime or the picturesque in nature is much more rare in England, except on the sea-coast, than in America; but there is every where a great deal of quiet, peaceful, graceful beauty which the works of man have generally added to, and which I remember but little like at home." In other words, wild scenery such as Yosemite and, in contrast, the sort of thing that he would seek to create in Central Park.

Shortly after the outbreak of the Civil War, Olmsted was appointed director of the United States Sanitary Commission, predecessor of the American Red Cross, an appallingly difficult job that he handled with distinction, and that all but ruined his health. In 1863, when he resigned and went west to take over Mariposa, he met Starr King, head of the California Commission (who doubtless told him something of the glories of Yosemite). Charles Eliot Norton described his appearance at this

time: "All the lines of his face imply refinement and sensibility to such a degree that it is not till one has looked through them to what is beneath, that the force of his will and the reserved power of his character become evident." He had already shown these qualities in his government service. He would show them again as he planned the future of Yosemite.

In the summer of 1864, accompanied by his family and a group of friends, Olmsted got his first view of the valley. En route the party explored the Mariposa Big Trees and enjoyed a visit from Clarence King, just back from the high country, who "spent several days in camp squiring the ladies on rides and entertaining them with stories of his adventures." When at length they reached the valley itself, the impact was overwhelming: "It is in no scene or scenes the charm consists, but in the miles of scenery where cliffs of awful height and rocks of vast magnitude and of varied and exquisite coloring, are banked and fringed and draped and shadowed by the tender foliage of noble and lovely trees and bushes, reflected from the most placid pools, and associated with the most tranquil meadows, the most playful streams, and every variety of soft and peaceful pastoral beauty.

"The union of the deepest sublimity with the deepest beauty of nature, not in one feature or another, not in one part or one scene or another, not in any landscape that can be framed by itself, but all around and wherever the visitor goes, constitutes the Yo Semite the greatest glory of nature."

After leaving the valley, Olmsted joined Professor Brewer, recently returned from leading the Geological Survey expedition that Clarence King describes so dramatically in *Mountaineering in the Sierra Nevada*. Together they climbed among the high peaks, which impressed Olmsted as they had King with their variety of form: "some being of grand simplicity, while others are pinnacled, columnar, castellated and fantastic." In all his travels, this was the most awesome scenery he had ever encountered.

Olmsted's concern with the influence of the natural scene on the mind of man went very deep. He had always been aware of the limited power of words to convey the total impact of a beautiful landscape. In writing about England, he had made precisely the same observation that he would reiterate twelve years later in his official report on Yosemite: "Beauty, grandeur, impressiveness in any way, from scenery, is not often to be found in a few prominent, distinguishable features, but in the manner and the unobserved materials with which these are connected and combined. Clouds, lights, states of the atmosphere, and circumstances that we cannot always detect, affect all landscapes. . . ." (It might be Ansel Adams speaking.)

Olmsted's approach to landscape was not purely aesthetic. Everything he set his hand to was directly concerned with human welfare. So in his official report on the preservation of Yosemite for public purposes he writes: "If we analyze the operation of scenes of beauty upon the mind, and consider the intimate relation of the mind upon the nervous system and the whole physical economy, the

action and reaction which constantly occur between bodily and mental conditions, the reinvigoration which results from such scenes is readily comprehended." The great virtue of natural scenery, he believed, the secret of its restorative powers, lies in the fact that it is divorced from any utilitarian purpose, from any future goal. "It is for itself and at the moment it is enjoyed. The attention is aroused and the mind occupied without purpose, without a continuation of the common process of relating the present act or thought or perception to some future end. There is nothing else that has this quality so purely. . . . The enjoyment of scenery employs the mind without fatigue and yet exercises it; tranquillizes it and yet enlivens it; and thus, through the influence of the mind over the body, gives the effect of refreshing rest and reinvigoration to the whole system."

Olmsted also looked upon the Yosemite reserve as "a museum of natural science" in which, for example, rare species of plants endangered by the invasion of exotics would be protected—thus anticipating the current view of our parks and wilderness areas as "living museums." The point is worth stressing, since it is often said that the first two parks, Yosemite and Yellowstone, were established for the sake of their "natural curiosities" rather than to save wilderness as such. True, this was the main motivation, but in the case of Yosemite it was by no means the only one.

As a young man, Olmsted's pleasure in the splendid private parks of England had been tempered by the realization that they could be enjoyed only by the rich and powerful, a minute proportion of the population. The great mass of society, including those who would most benefit from them, were excluded. He was determined that this should not happen in America. In granting Yosemite Valley and the Mariposa Big Trees to the state of California, for public use and recreation, the United States Congress set a precedent for the founding of the first national park, Yellowstone, eight years later, and eventually for the whole national park system.

Olmsted was ahead of his time in recognizing man's joy in nature as an integral part of his culture, comparable to his appreciation of art or literature or music. "The power of scenery to affect men is, in a large way, proportionate to their civilization and the degree to which their taste has been cultivated." This does not mean, however, that such an aesthetic experience need be confined to the privileged few.

Olmsted was not primarily a writer; his extraordinary accomplishments are to be read in the landscape itself. Yet few writers have had a more sensitive response to nature, or held to their beliefs with a fiercer conviction. In 1890, when the high country surrounding Yosemite Valley was finally joined with it to make a national park after years of mismanagement of the valley by the state, he wrote a pamphlet, *Governmental Preservation of Natural Scenery*, in which he looked back across a quarter of a century to an experience that the hurried tourist could never know. There is an almost religious quality in his growing love for the valley, his discovery of new levels of beauty and meaning on each visit, his sadness at depart-

ing with so much still beyond his grasp. "I felt the charm of the Yosemite much more at the end of a week than at the end of a day, much more after six weeks when the cascades were nearly dry, than after one week, and when, after having been in it, off and on, several months, I was going out, I said, 'I have not yet half taken it in.'"

During the decade following the cession of Yosemite Valley to the state of California, its fame spread rapidly throughout the country. In 1866 there appeared a charming travel book by Samuel Bowles of the *Springfield* [Massachusetts] *Republican*, who had visited the valley with Olmsted and a large party the previous summer, and who subsequently became one of his warmest friends and supporters. Bowles's reaction to such scenery was one of inexpressible awe: "The Yosemite!" he begins. "As well interpret God in thirty-nine articles as portray it to you by word of mouth or pen." But he goes on to do his best, with considerable success, and moreover has the foresight to recognize in the saving of Yosemite a precedent for similar action elsewhere: Niagara Falls, the Adirondacks, the Maine woods.

More reports were published in the late 1860s and early 1870s. Photographs by C. E. Watkins, made as early as 1863, were exhibited in New York and at the 1867 World Exhibition in Paris. Paintings by Thomas Hill, a Paris-trained San Francisco artist, were sold in reproduction throughout the country; huge romantic pictures by the famous Albert Bierstadt impressed and delighted easterners who had never seen the West. The first Yosemite guidebook was published in 1868; the following year

the railroad reached Stockton and immediately swelled the volume of tourists. In 1874, at the end of the decade, the first road for wagons and stagecoaches entered the valley.

The main event of this period—in light of Yosemite's future—occurred with no fanfare whatever. In the summer of 1868 a thirty-year-old Scot named John Muir took ship for California, following his now-famous "thousand-mile walk" from Wisconsin to the Gulf of Mexico. Muir's passion for wilderness, his daring as a mountaineer, stemmed from his boyhood in Scotland, where he had gloried in "the awful storms thundering on the black headlands and craggy ruins of the old Dunbar Castle," as he and his rugged playmates "tried to see who could climb highest on the crumbling peaks and crags." When the family moved to a frontier farm in Wisconsin, he had endured backbreaking toil and regular beatings by his fanatical father, but eventually escaped to work his way through the university. Here he received his first lesson in botany, which sent him "flying to the woods and meadows in wild enthusiasm." Now, in the Sierra, he had found his true home. By spring he had a job sheepherding in the high country. In mid-July, he got his first sight of the summit peaks and Yosemite Valley. "I shouted and gesticulated in a wild burst of ecstasy." His career as a naturalist and a writer had begun.

In later years, John Muir would write of the Sierra as no one has done before or since; his name would be forever inseparable from the Range of Light. But he could

never be described as a "natural writer"—whatever that term means. At no loss for words in conversation, in his journals, in private letters, he seems to have frozen up when writing for publication, becoming, he confessed, "slow as a glacier." Happily, a professor at the University of Wisconsin, James Davie Butler, had not only introduced him to the writings of Emerson and Thoreau but persuaded him to keep a journal, as they did—a source of future books. Like Thoreau, he found his inspiration in nature, and he took notes on the spot, in all weathers, his fingers sometimes numb with the cold. The difference is that Thoreau, a systematic craftsman, would conscientiously shape and polish these notes at day's end for entry in his massive journal, whence they could later be lifted for publication, often word for word. Muir was more haphazard, and more than forty years passed before he reworked this early journal to become *My First Summer in the Sierra*—a book that nonetheless retains all the joy and freshness of any first encounter.

In the fall of 1871, at the urging of his friends, Muir published three reports on Yosemite in the *New York Daily Tribune*. The following spring he wrote a series of articles in the *Overland Monthly*, which under the editorship of Bret Harte had become the leading magazine on the Pacific Coast. Beginning with a dramatic account of a great storm and flood in Yosemite Valley, they impressed and thrilled his readers. Two years later he published a series on glaciers, which led the great authority on glacial action, Louis Agassiz, to remark that "Muir is studying to greater purpose and with greater results than anyone

else has done." He was moving inevitably toward his principal lifework: the understanding and preservation of our wilderness through scientific knowledge and the power of the pen. His purpose was "to entice people to look at Nature's loveliness." It was a formidable assignment. "The love of Nature among Californians," he remarked, "is desperately moderate." He sought to stir them up with a fiery article in the Sacramento paper, entitled "God's First Temples: How Shall We Preserve Our Forests?" In it he attacked the sheepmen who, by overgrazing and burning the mountain pastures, were destroying both the woods and the watersheds, to the eventual impoverishment of the whole state. The article focused widespread attention on Muir as the leader of what would become a national conservation movement.

Muir could not yet see himself as a professional writer. "After my first article I was greatly surprised to find that everything else I offered was accepted and paid for. That I could earn money simply with written words seemed very strange." It was not, however, his main means of support. He had married the daughter of one of the first and most successful horticulturalists in California, and for the next ten years he ran a fruit farm acquired from his father-in-law, "until I had more money than I thought I would ever need for my family or for all expenses of travel and study." Now he could leave the farm and return to his true calling.

He had never really abandoned it. Whenever the orchards and vineyards did not need his personal attention, he had hastened to the high country, pushing his explor-

ations farther and farther. The mountains were his sure source of inspiration, literally his breath of life. The higher the source, the greater is the power of his prose. After a particularly harassing climb, or perhaps the discovery of a rare flower or the sight of a gorgeous sunset, his words flow and overflow and effervesce in a rushing, aerated stream, until one feels that a trout could live happily in every paragraph. On a mid-December morning he writes from Yosemite Valley to the famous botanist Asa Gray: "I had some measurements to make about the throat of the South Dome, so yesterday I climbed there, and then ran up to Cloud's Rest for your Primulas. . . . I witnessed one of the most glorious of our mountain sunsets; not one of the assembled mountains seemed remote — all had ceased their labor of beauty and gathered around their parent sun to receive the evening blessing. . . . I ran home in the moonlight with your sack of roses slung on my shoulder by a buckskin string — down through the junipers, down through the firs, now in black shadow, now in white light, past great South Dome white as the moon, past spirit-like Nevada, past Pywiack, through the groves of Illilouette and spiry pines of the open valley, star crystals sparkling above, frost crystals beneath, and rays of spirit beaming everywhere."

Toward the end of the decade, an event occurred that was not only a lucky break for Muir but for America and the world. In the summer of 1889 he revisited his old haunts in Yosemite, accompanied by an editor of *Century*

magazine, Robert Underwood Johnson, himself an ardent conservationist. Muir had been increasingly disturbed by the logging and the overgrazing by the huge flocks of sheep—"hoofed locusts" as he called them—in the high country surrounding the valley, as well as the mismanagement of the valley itself under state jurisdiction. Now Johnson suggested that he write two articles describing the glories of these mountains as only he could do, and recommending the expansion of the state reserve into a national park, to include some 1,500 square miles. On October 1, 1890, largely through the efforts of these two men, Yosemite National Park was born.

This is not, of course, the end of the story. The park existed on paper, but could it be protected in fact? Aware of the power of commercial interests, a group of California mountaineers and outdoorsmen united to form a Yosemite Defense Association. On June 4, 1892, the new association was legally incorporated under the name of the Sierra Club, with twenty-seven members and John Muir as president. Since that time, faithful to the principles of its founder, the club has grown to become one of the world's greatest conservation organizations. Among its many distinguished leaders, none has served more brilliantly, or with more devotion, than Ansel Adams. Thanks to his genius with the camera, to his passion for preserving "the American earth," his name today is as closely associated with Yosemite and the Sierra Nevada as that of John Muir himself.

Yosemite and the Range of Light

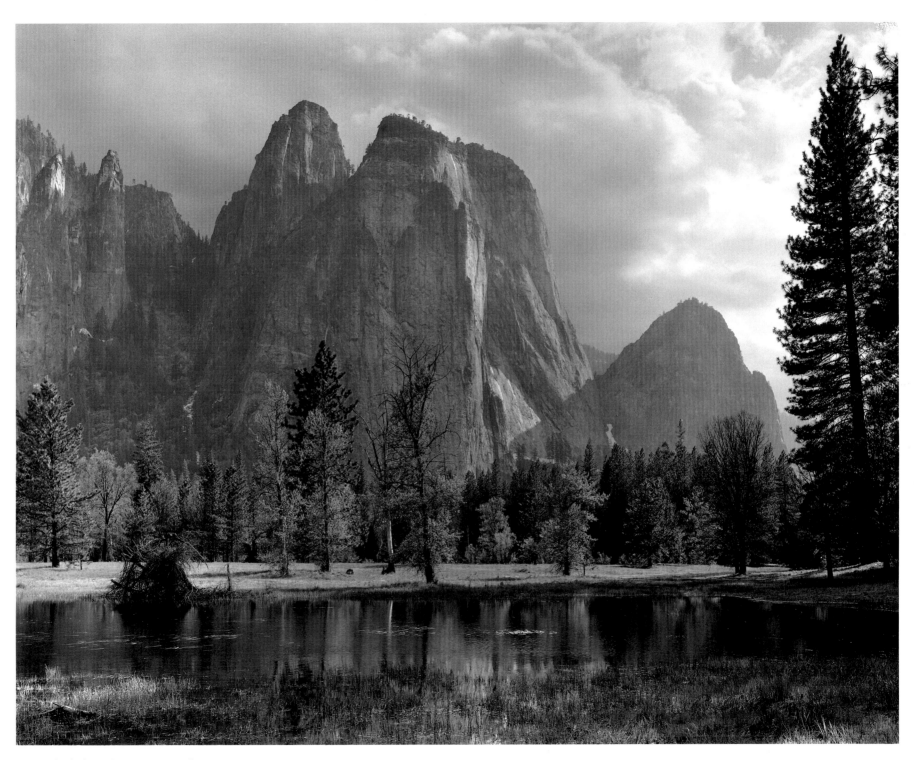

10. *Cathedral Rocks, Yosemite Valley c.1949*

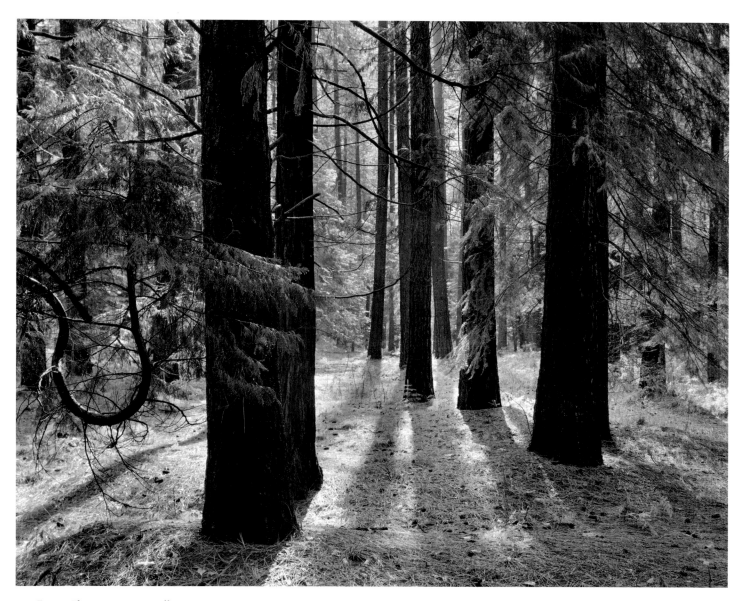

11. *Forest Floor, Yosemite Valley c.1950*

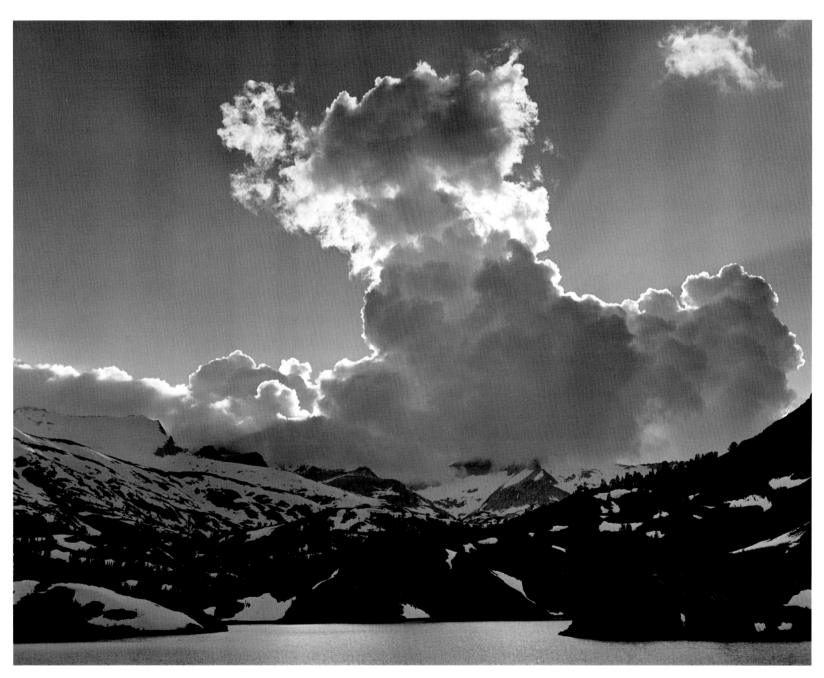

12. *Evening Cloud, Ellery Lake, Sierra Nevada 1934*

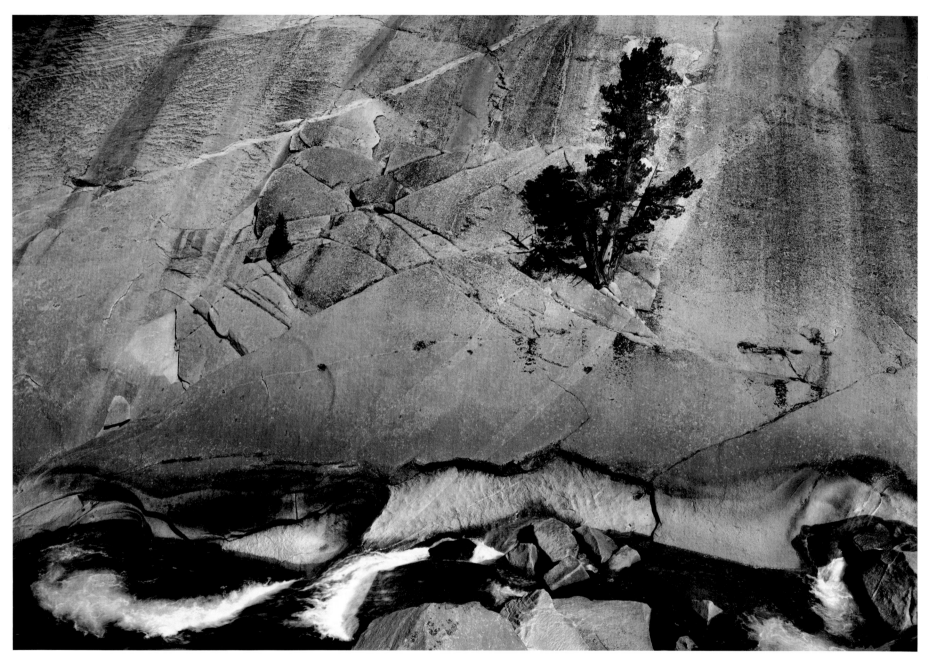

13. *Juniper, Cliffs and River, Upper Merced River Canyon, Yosemite National Park c.1936*

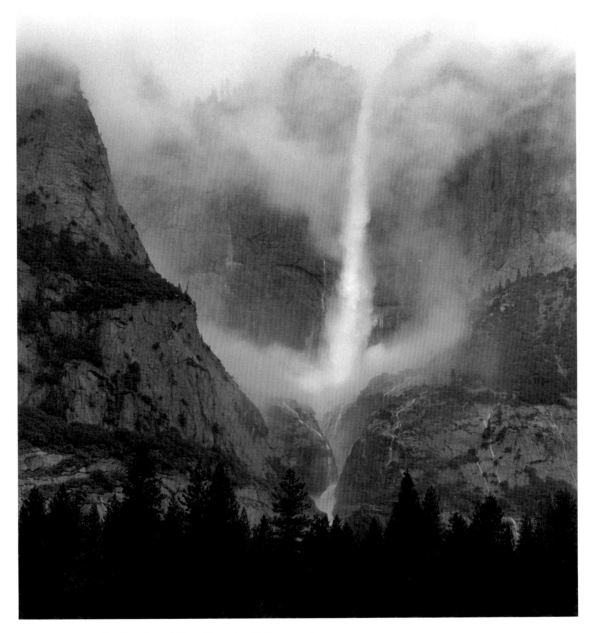

14. *Yosemite Falls, Clouds and Mist, Yosemite Valley c.1960*

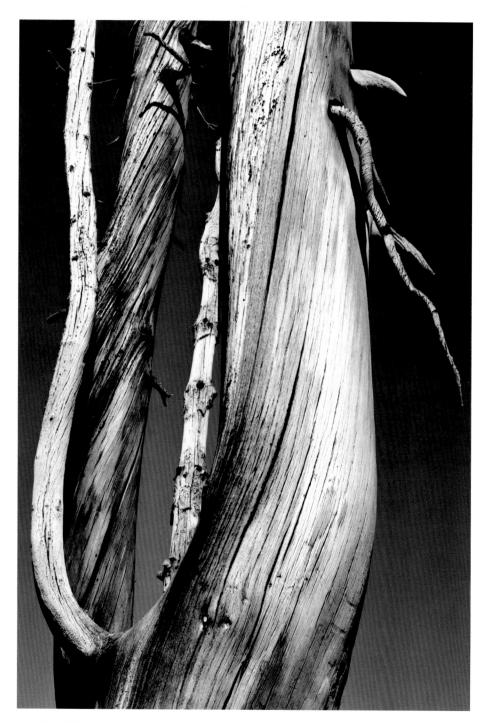

15. *Dead Tree, Dog Lake, Yosemite National Park 1933*

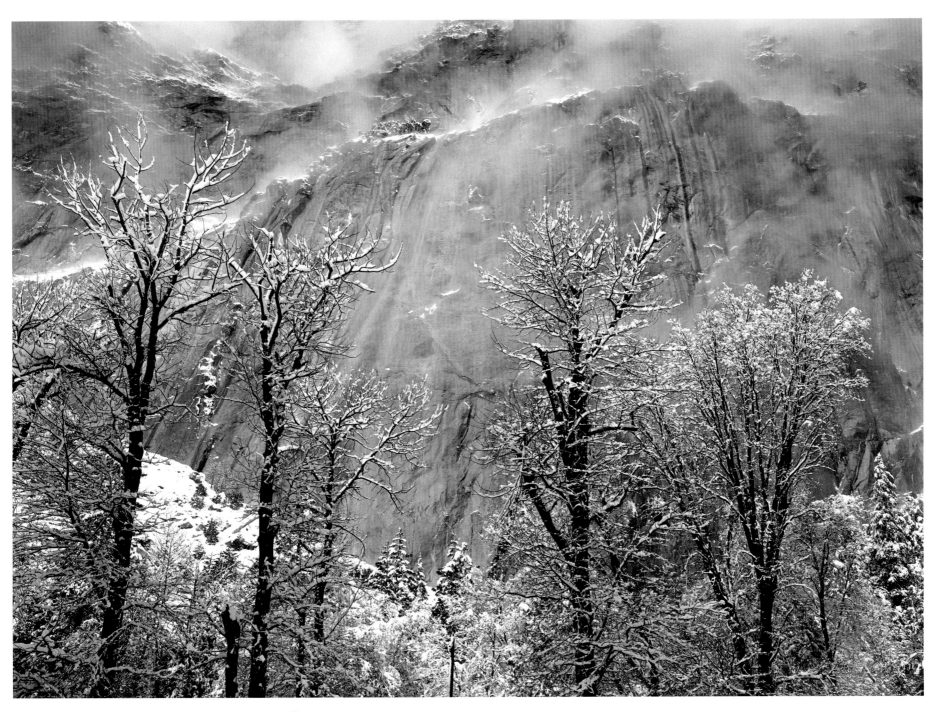

16. *Trees and Cliffs of Eagle Peak, Winter, Yosemite Valley c.1935*

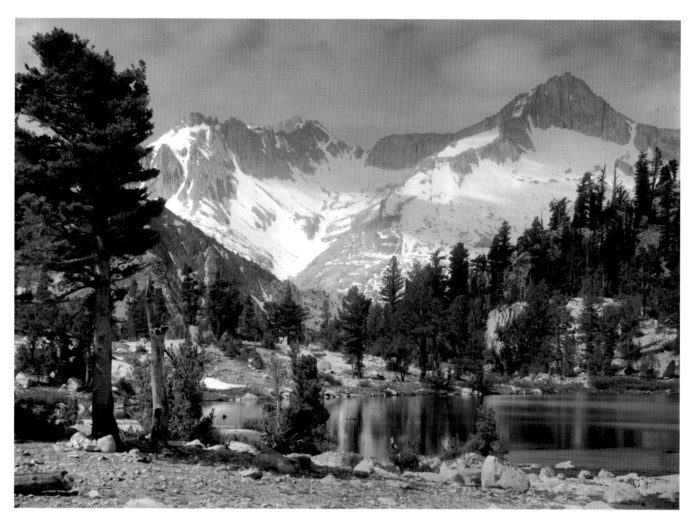

17. *Mount Brewer and Bullfrog Lake, Kings Canyon National Park* c.1925

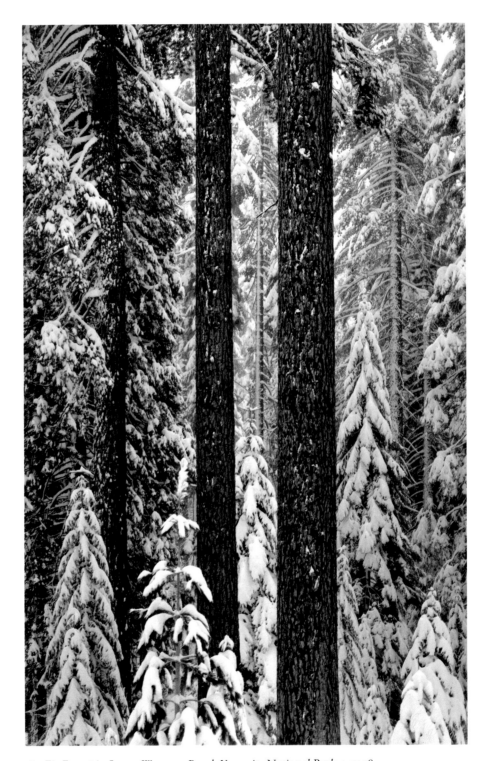

18. *Fir Forest in Snow, Wawona Road, Yosemite National Park c.1948*

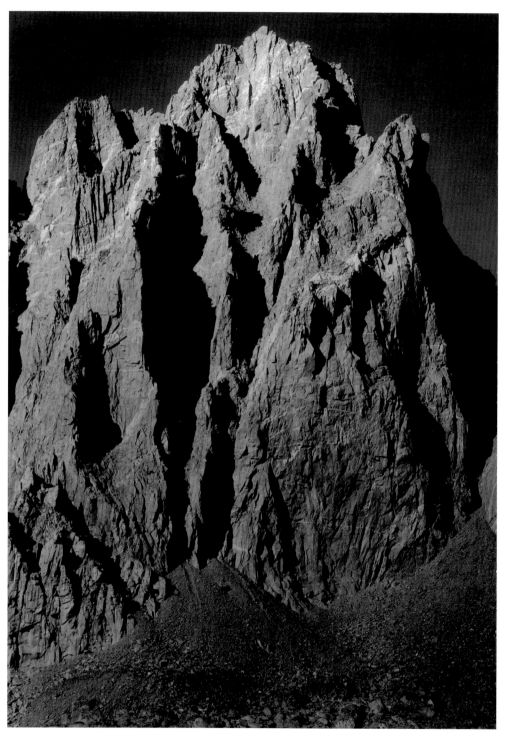

19. Mount Winchell, Kings Canyon National Park c.1933

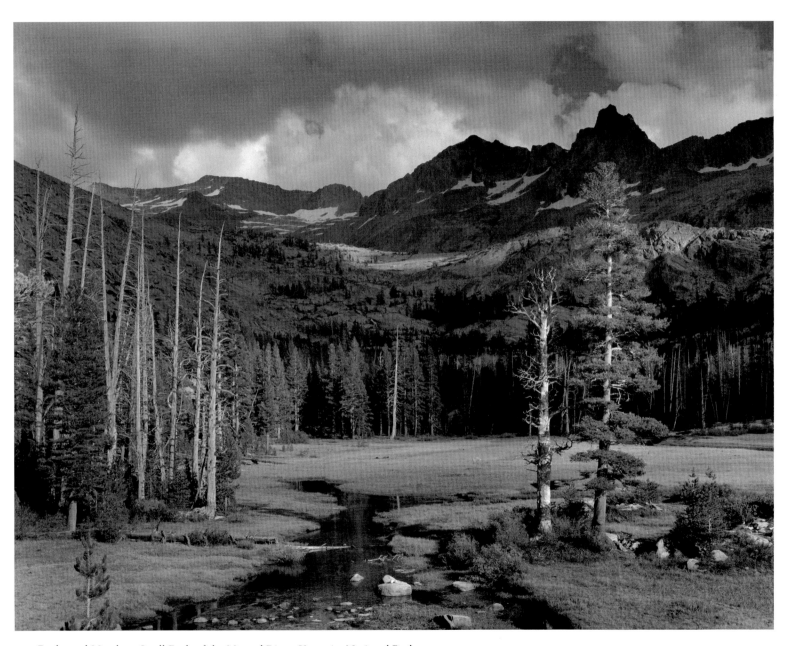

20. *Peaks and Meadow, Lyell Fork of the Merced River, Yosemite National Park c.1943*

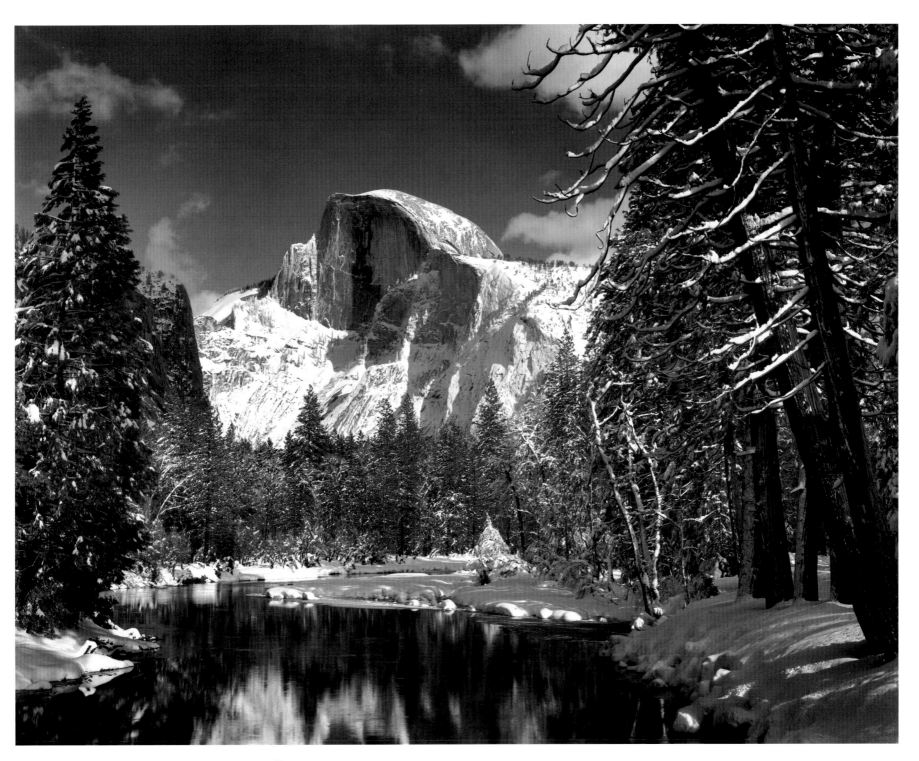

21. *Half Dome, Merced River, Winter, Yosemite Valley c.1938*

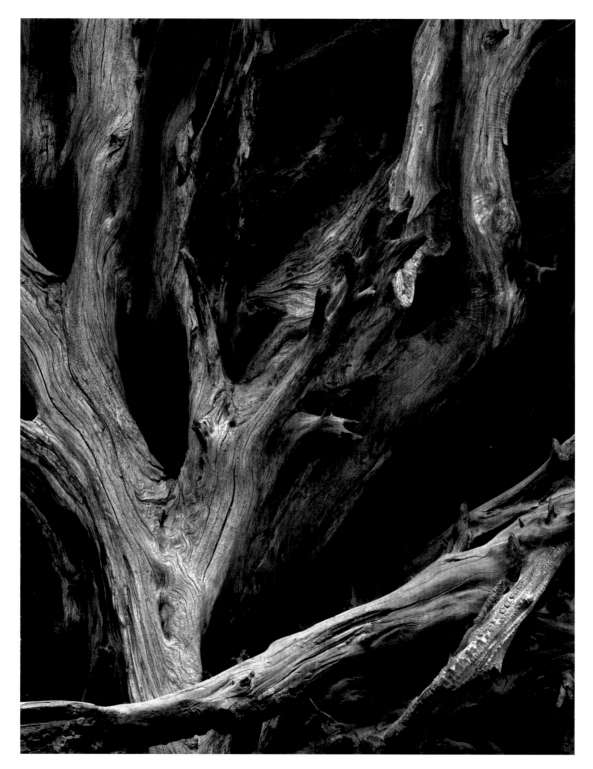

22. *Sequoia Gigantea Roots, Yosemite National Park c.1950*

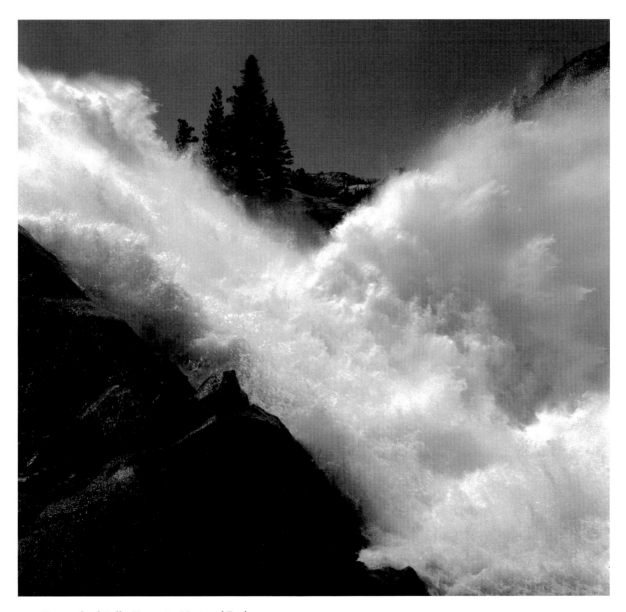

23. *Waterwheel Falls, Yosemite National Park c.1940*

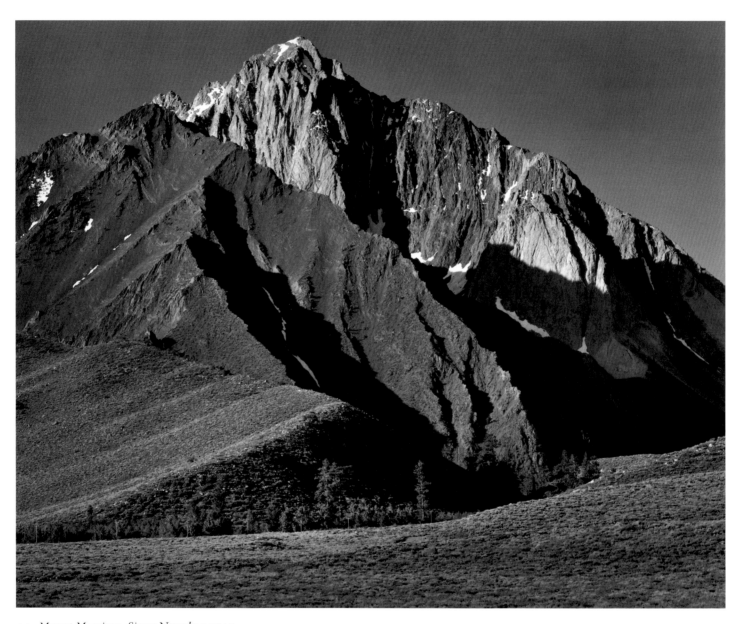

24. *Mount Morrison, Sierra Nevada c. 1945*

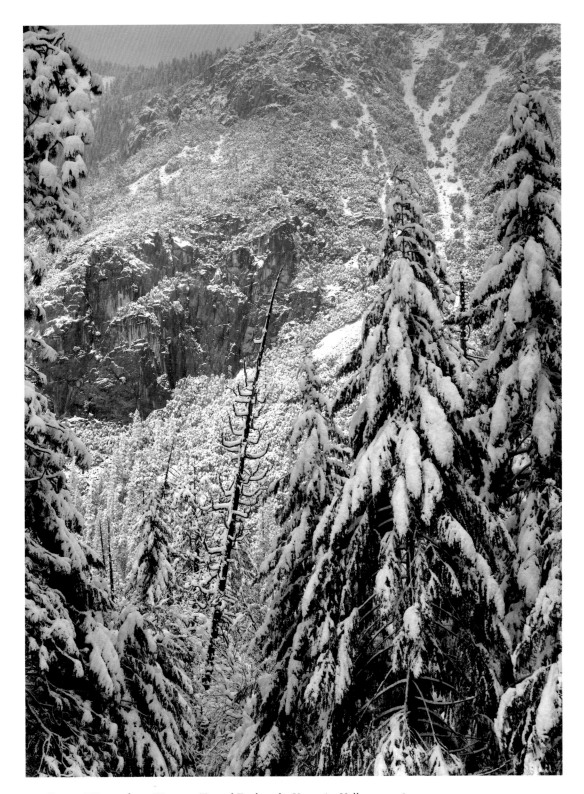

25. *Forest, Winter, from Wawona Tunnel Esplanade, Yosemite Valley c.1948*

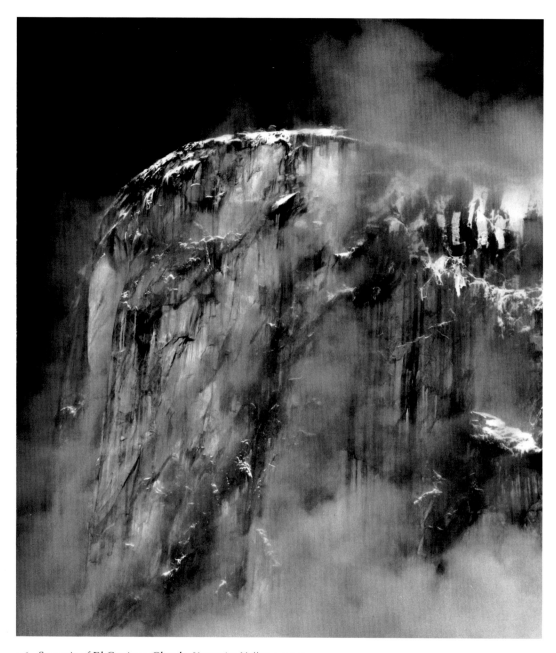

26. *Summit of El Capitan, Clouds, Yosemite Valley c.1970*

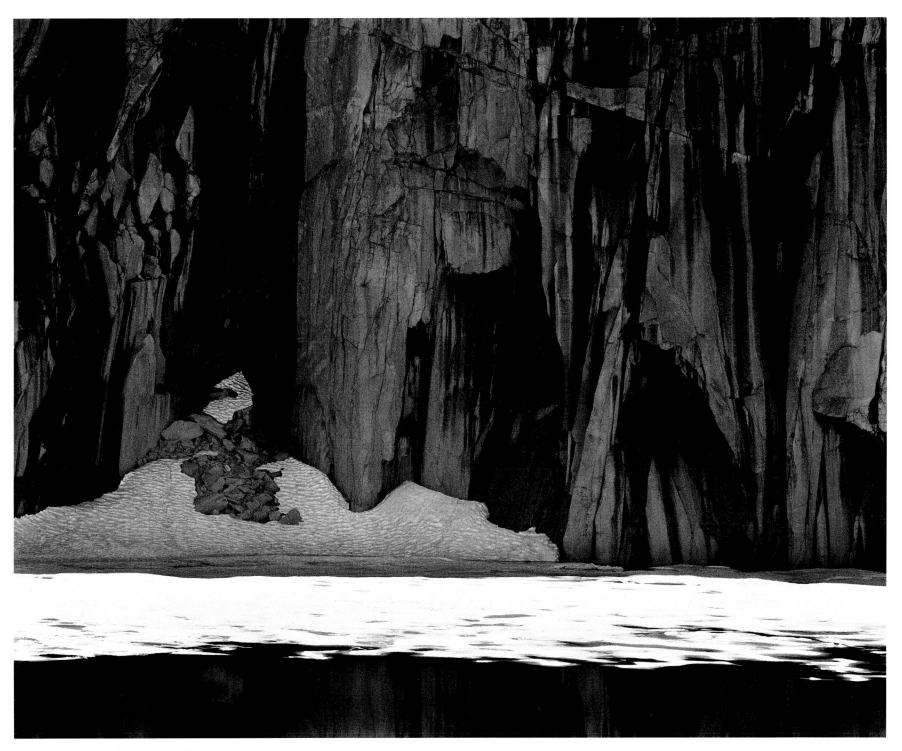

27. *Frozen Lake and Cliffs, Sequoia National Park 1932*

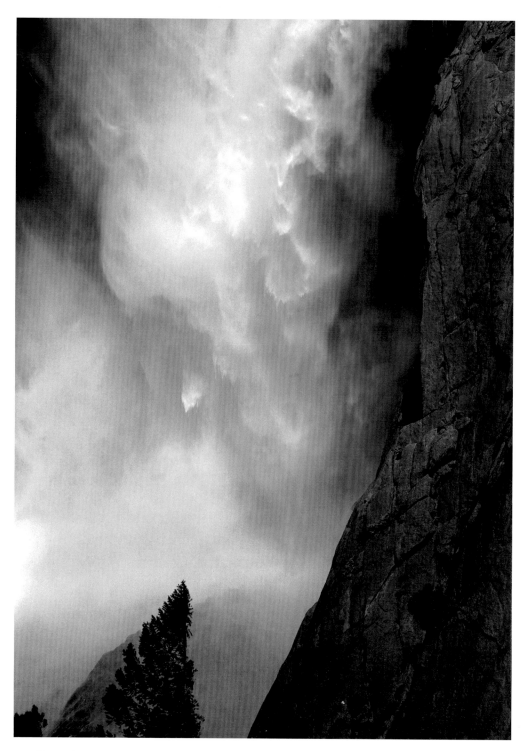

28. *Base of Upper Yosemite Fall, Yosemite Valley c.1950*

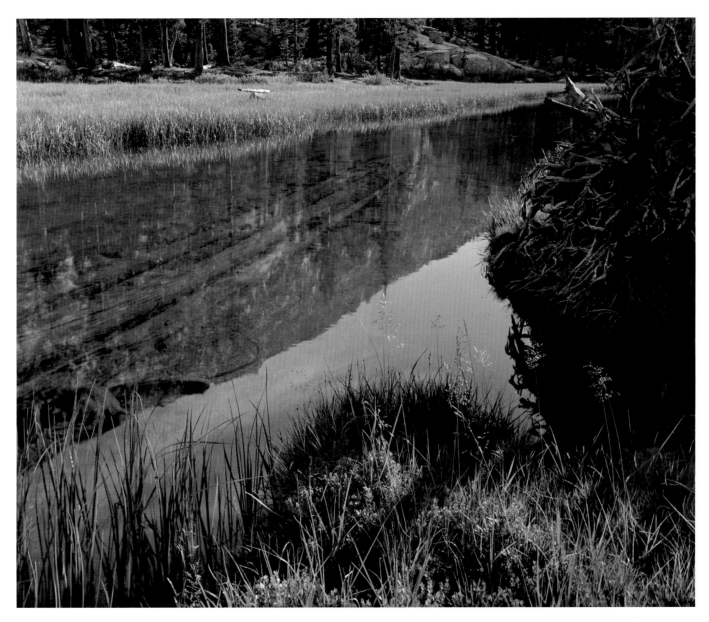

29. *Meadow and Stream, Lyell Fork of the Merced River, Yosemite National Park c.1943*

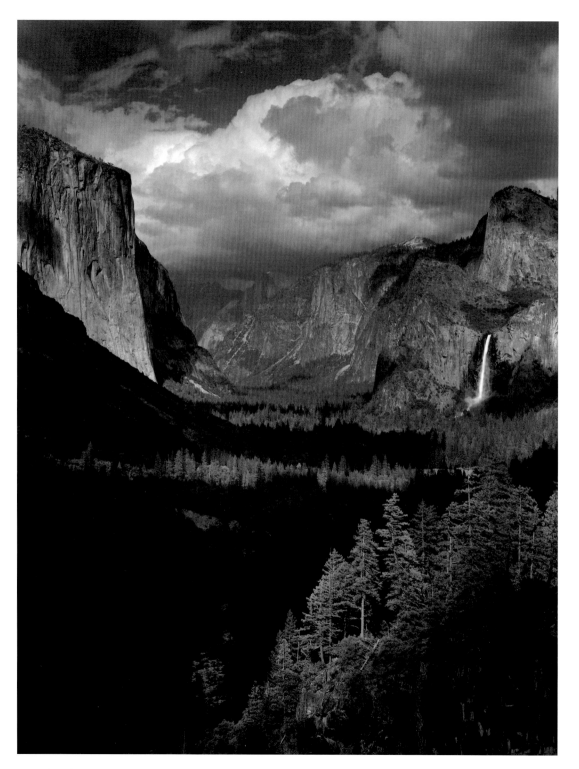

30. *Thunderstorm, Yosemite Valley 1945*

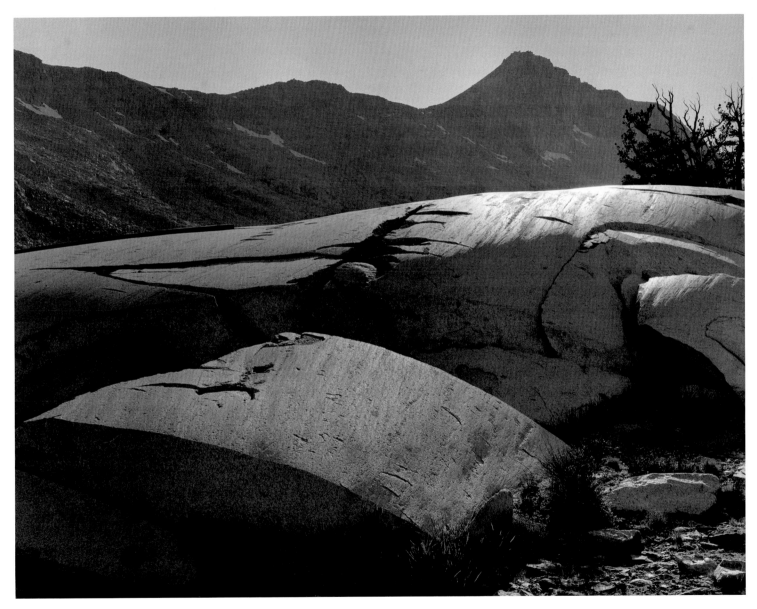

31. *Glacier Polish, Yosemite National Park c.1940*

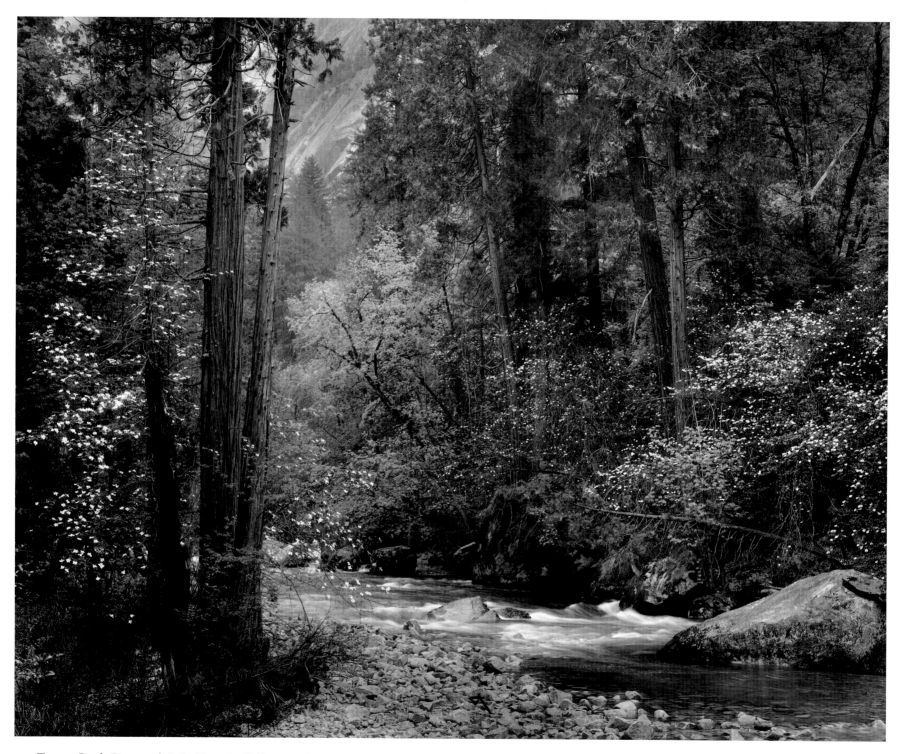

32. *Tenaya Creek, Dogwood, Rain, Yosemite Valley c.1948*

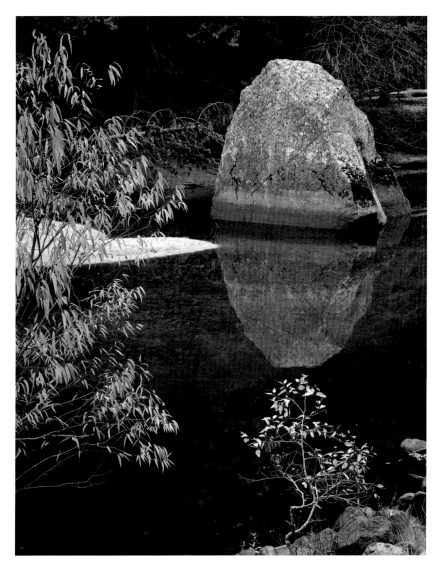

33. *Rock, Merced River, Autumn, Yosemite Valley c.1962*

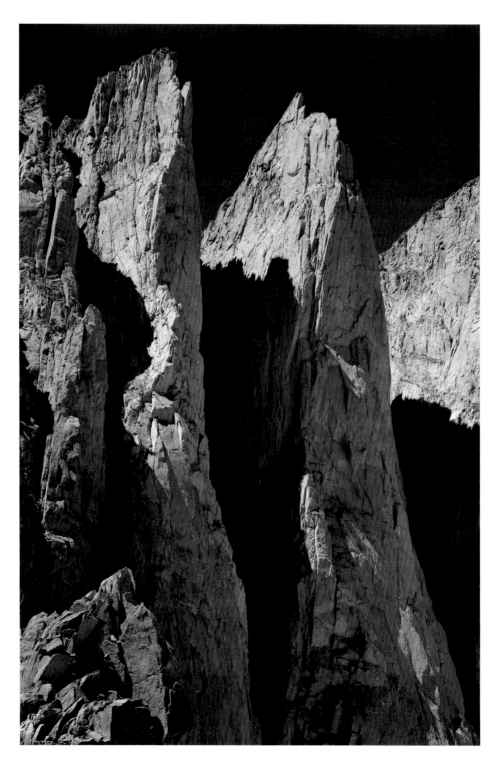

34. *Pinnacles, Mount Whitney, Sierra Nevada c.1940*

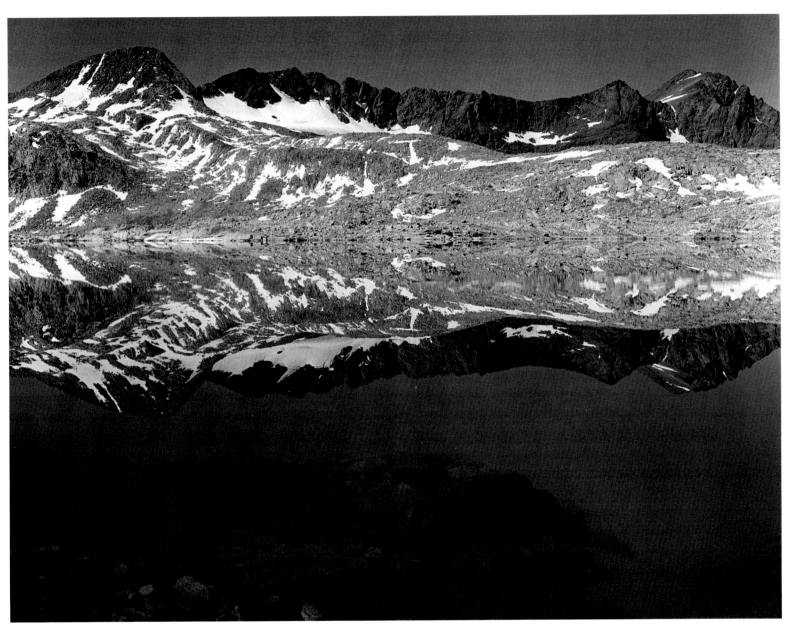

35. *Lake near Muir Pass, Kings Canyon National Park c.1933*

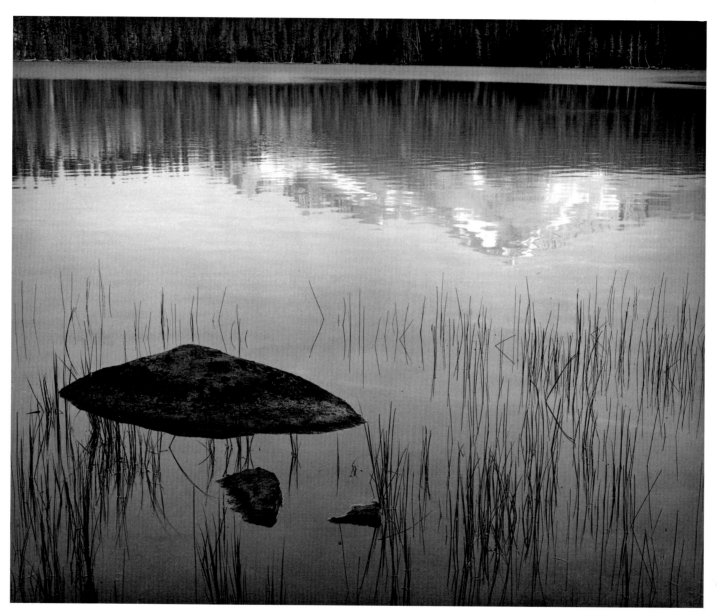

36. *Rock and Grass, Moraine Lake, Sequoia National Park c.1932*

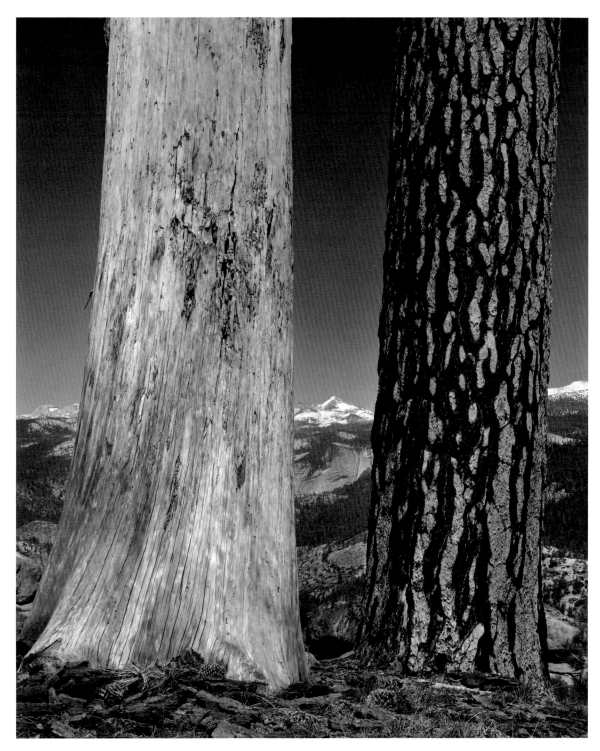

37. *Trees near Washburn Point, Yosemite Valley c.1945*

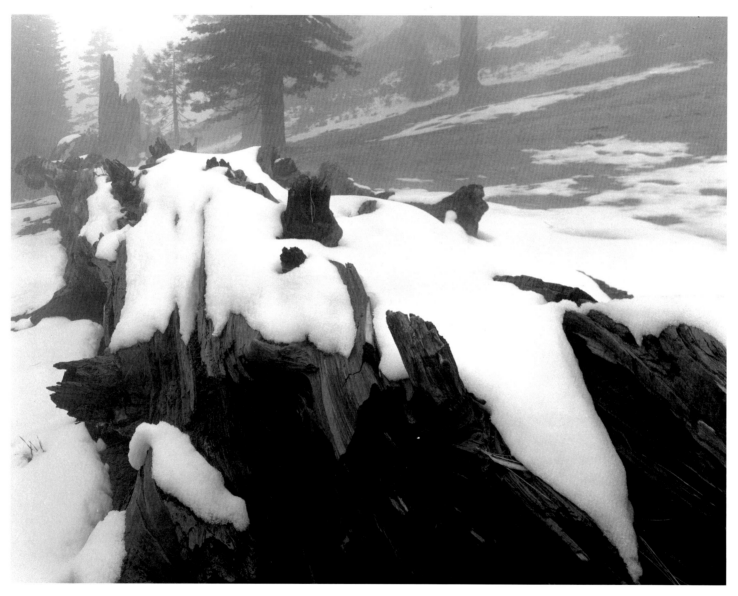

38. Morning Mist near Glacier Point, Winter, Yosemite Valley c.1970

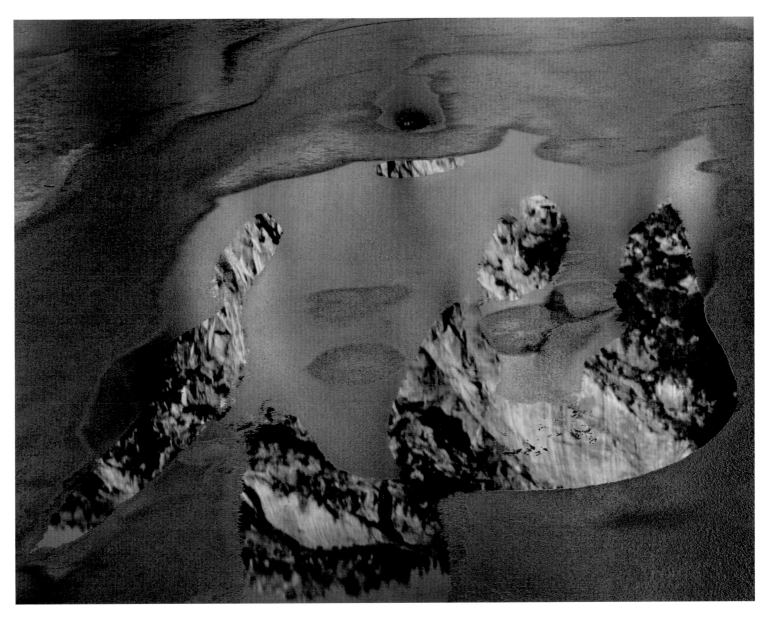

39. *Ice and Water Reflections, Merced River, Yosemite Valley c.*1942

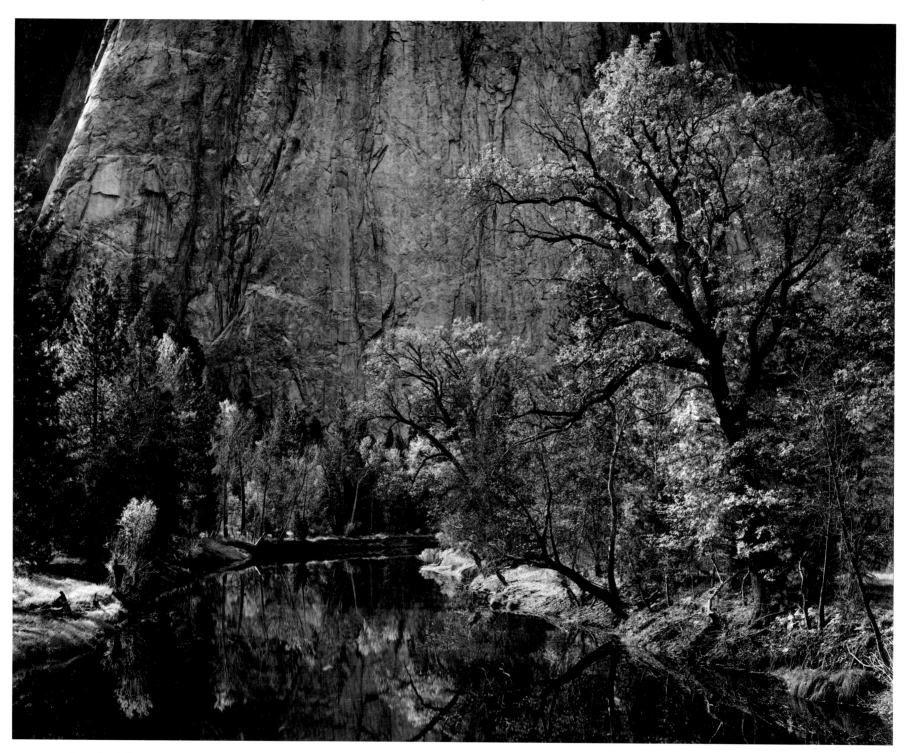

40. *Merced River, Cliffs, Autumn, Yosemite Valley 1939*

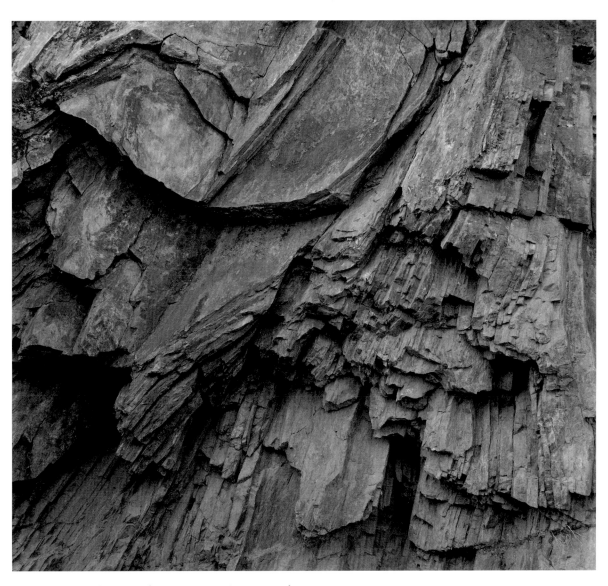

41. *Ancient Rocks, Merced River Canyon, Sierra Nevada c.1968*

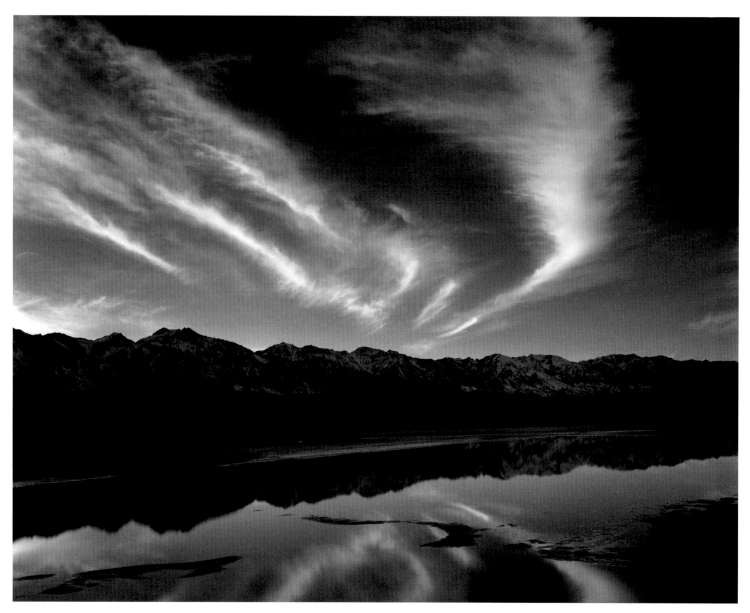

42. *Evening Clouds and Pool, East Side of the Sierra Nevada, from the Owens Valley c. 1962*

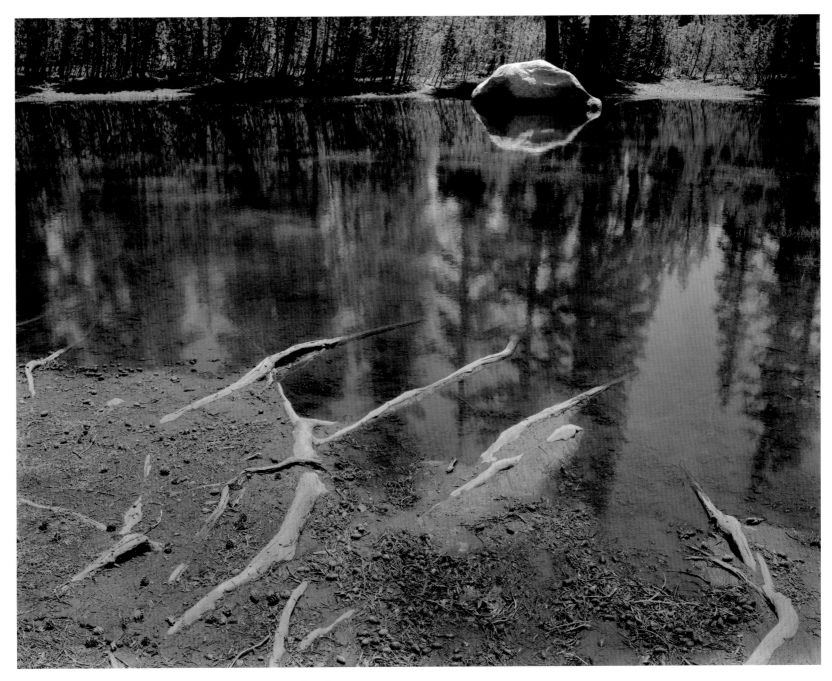

43. *Roots and Pool near Tenaya Lake, Yosemite National Park 1955*

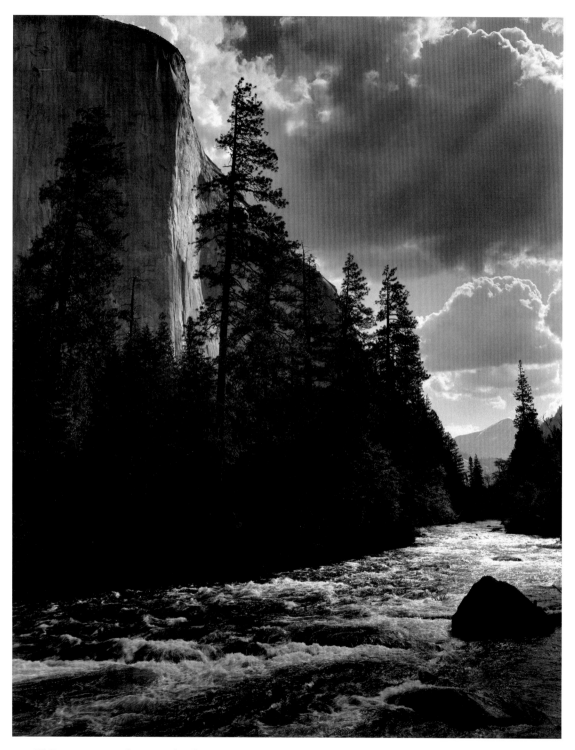

44. *El Capitan, Merced River, Clouds, Yosemite Valley c.1952*

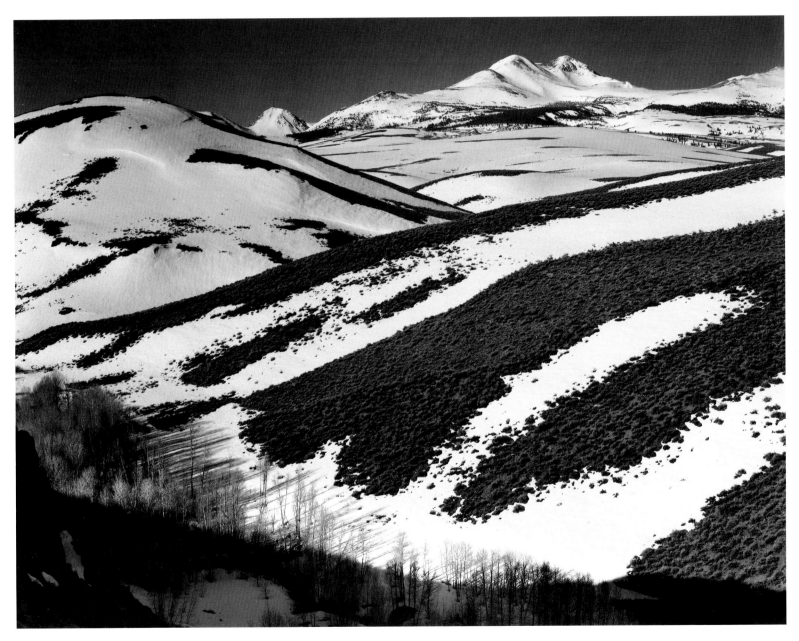

45. *Mountains from Conway Summit, Early Spring, Sierra Nevada 1952*

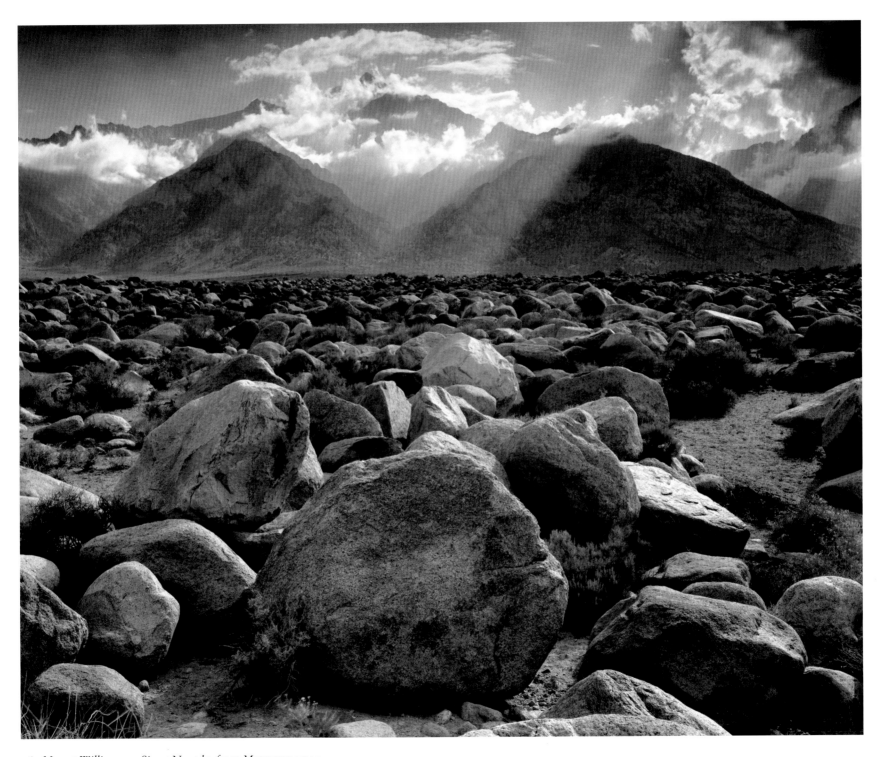

46. *Mount Williamson, Sierra Nevada, from Manzanar* 1944

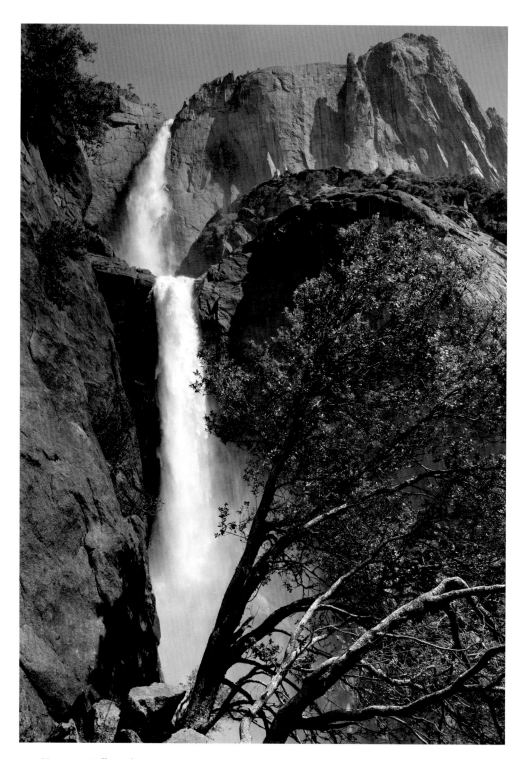

47. *Yosemite Falls and Point, Yosemite Valley c.1936*

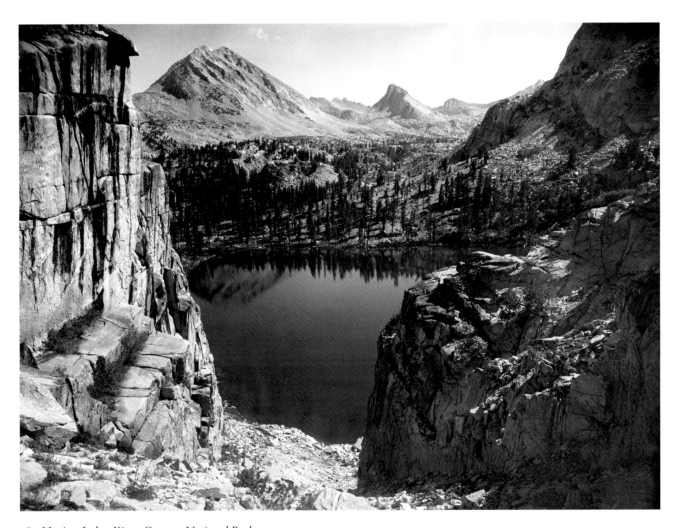

48. *Marion Lake, Kings Canyon National Park c. 1925*

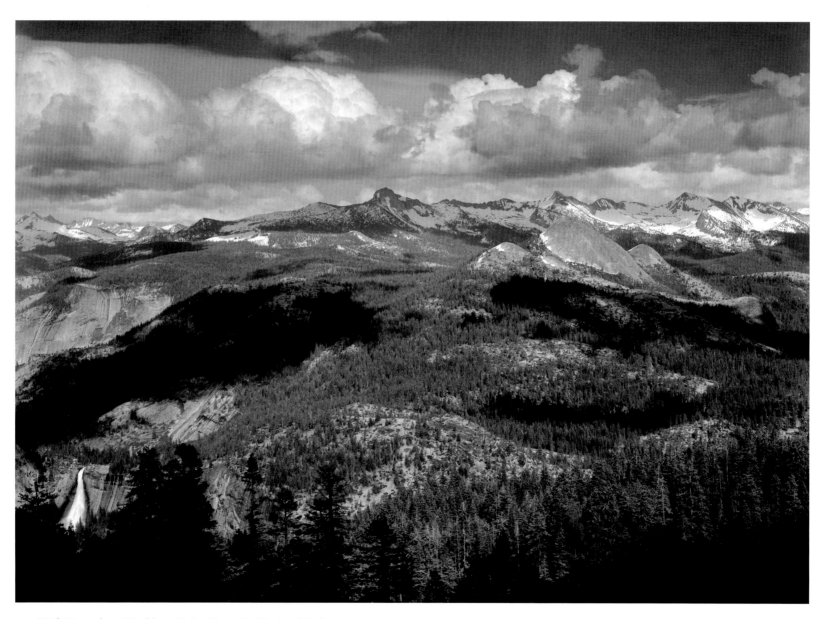

49. *High Sierra from Washburn Point, Yosemite National Park c.1935*

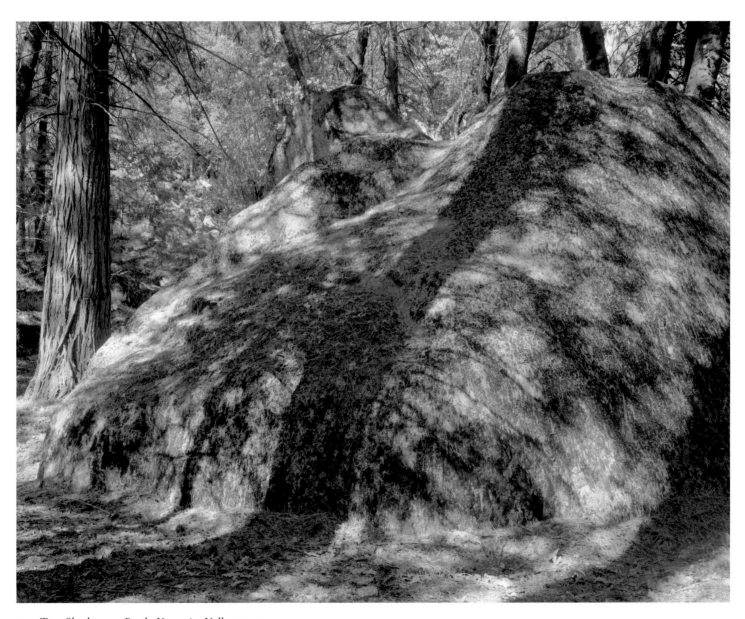

50. *Tree Shadow on Rock, Yosemite Valley c.1950*

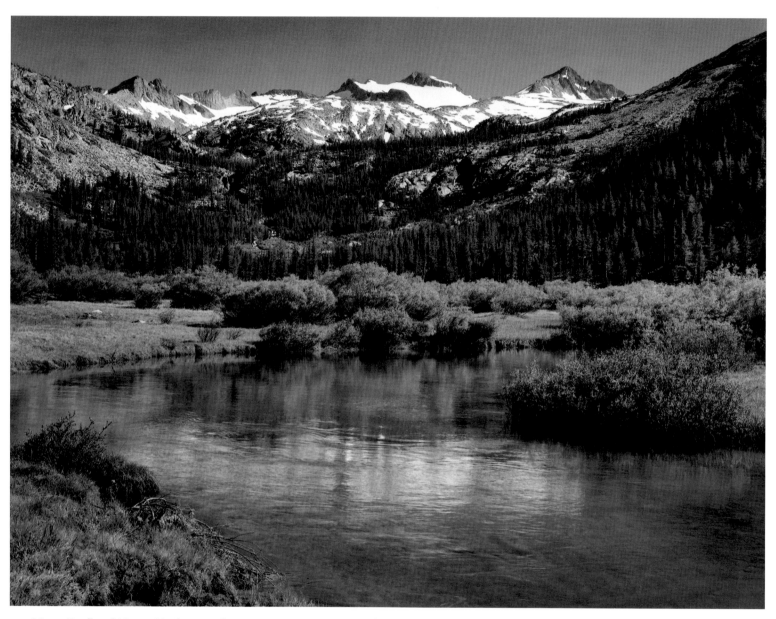

51. *Mount Lyell and Mount Maclure, Tuolumne River, Yosemite National Park c. 1936*

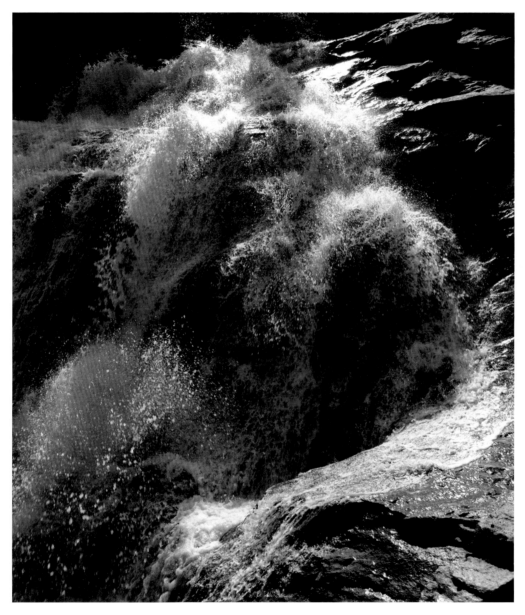

52. *Foresta Fall, Sierra Nevada c.1965*

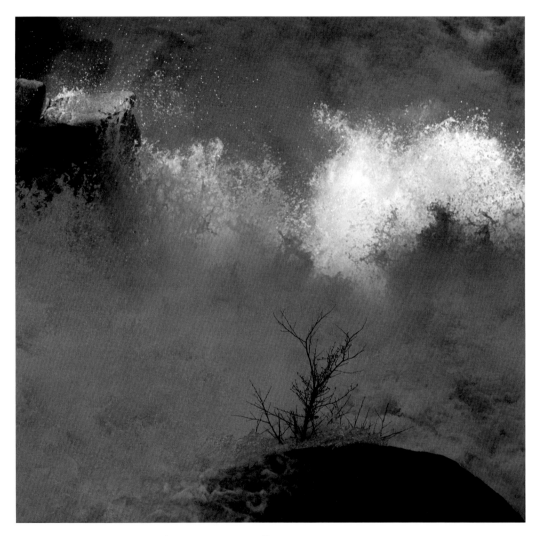

53. *Shrub and Rapids, Merced River, Yosemite Valley c. 1960*

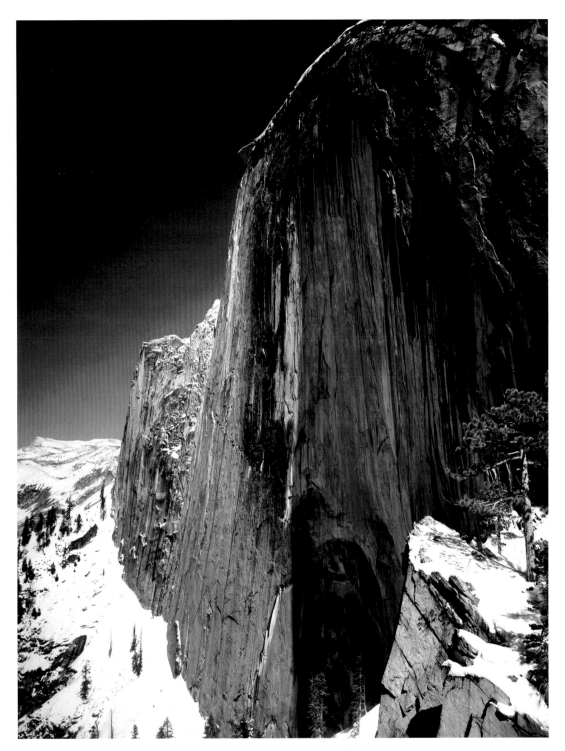

54. *Monolith, The Face of Half Dome, Yosemite Valley 1927*

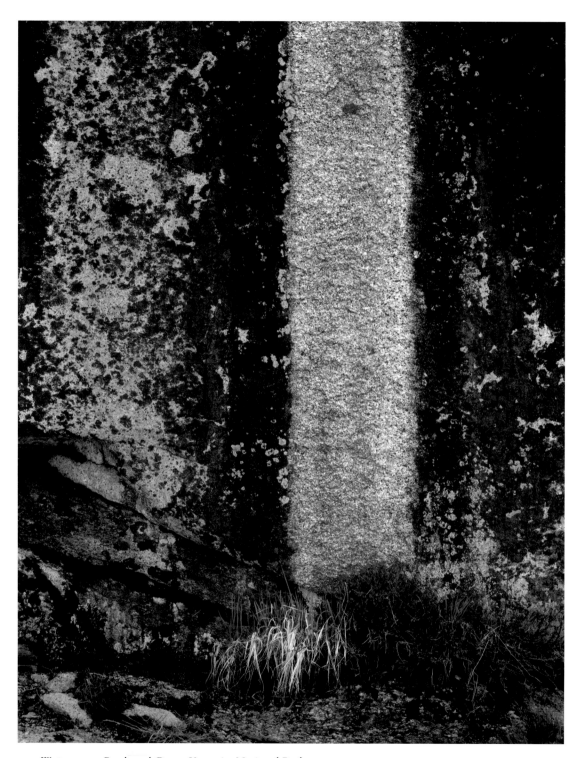

55. *Water-worn Rock and Grass, Yosemite National Park c.1943*

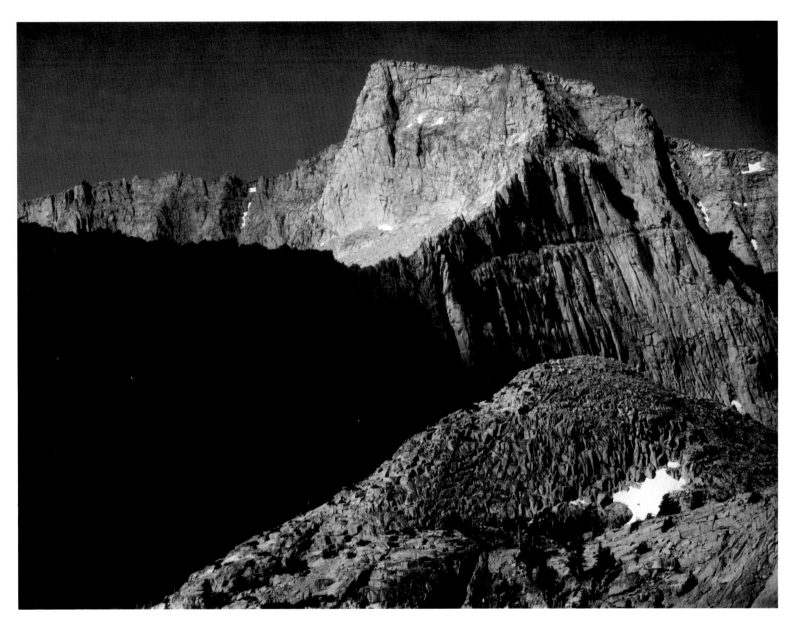

56. *Glacial Cirque, Milestone Ridge, Sequoia National Park c.1927*

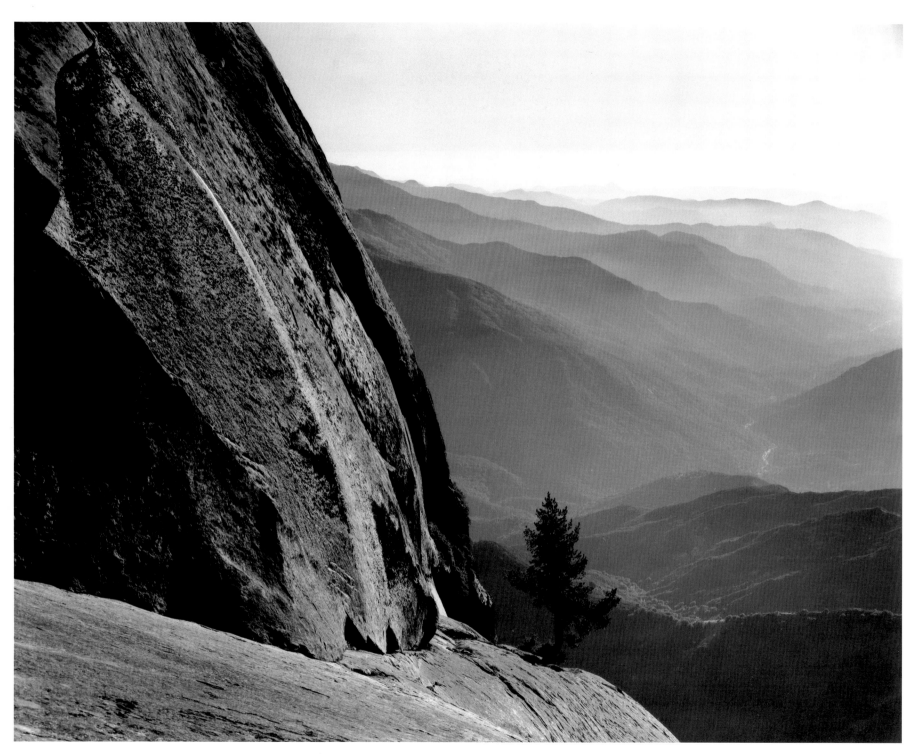

57. *Moro Rock, Sequoia National Park and Sierra Foothills c.1945*

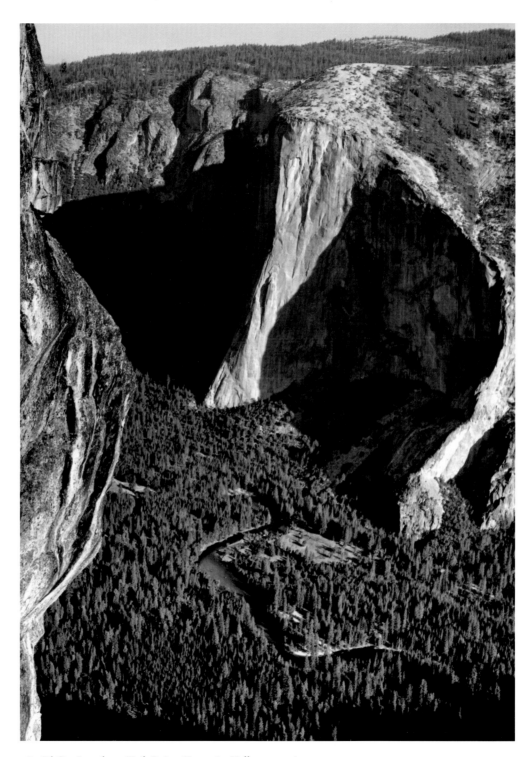

58. El Capitan from Taft Point, Yosemite Valley c.1936

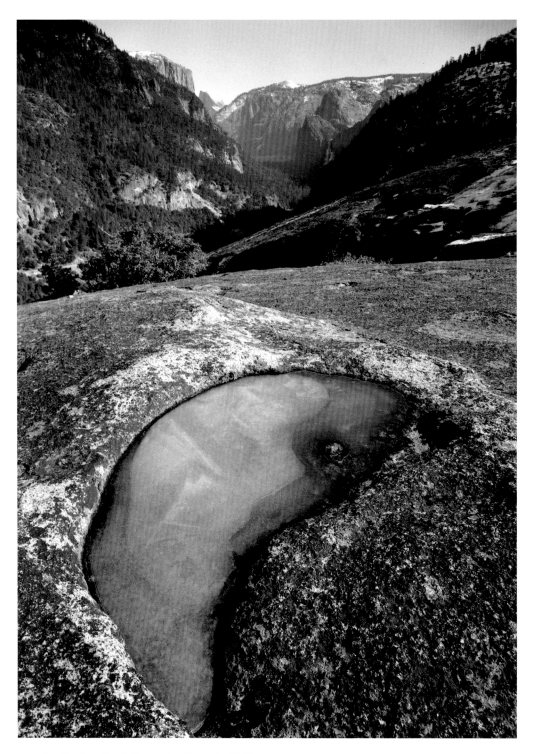

59. *Icy Pool on Bald Mountain, Yosemite Valley c.1947*

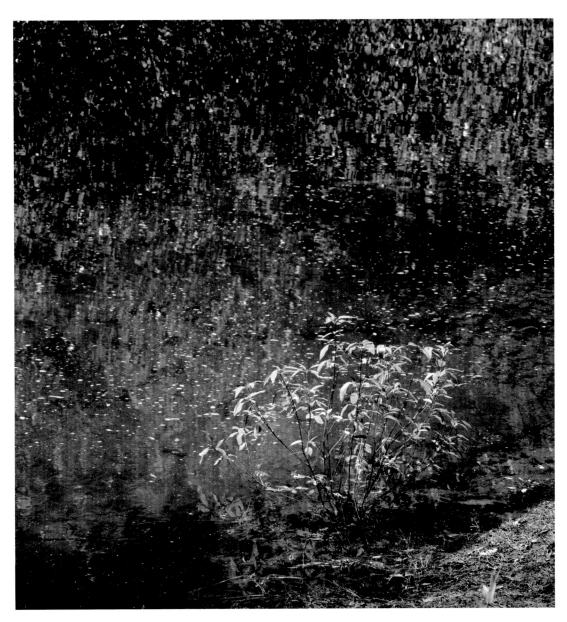

60. *Merced River Pool, Yosemite Valley c.1960*

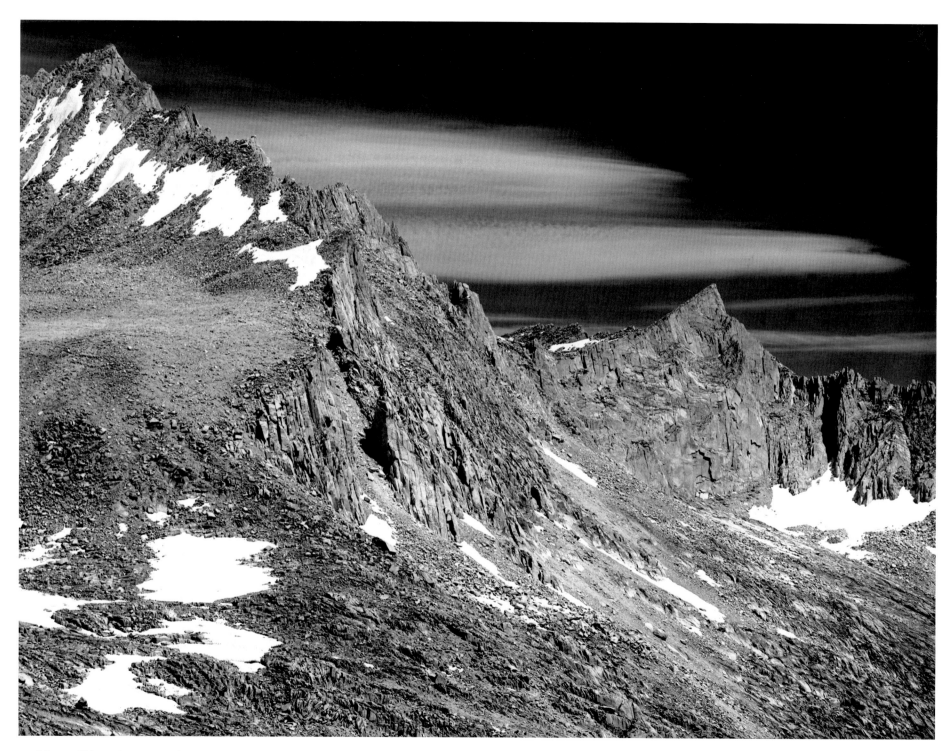

61. *Mount Abbott, Sierra Nevada c.1929*

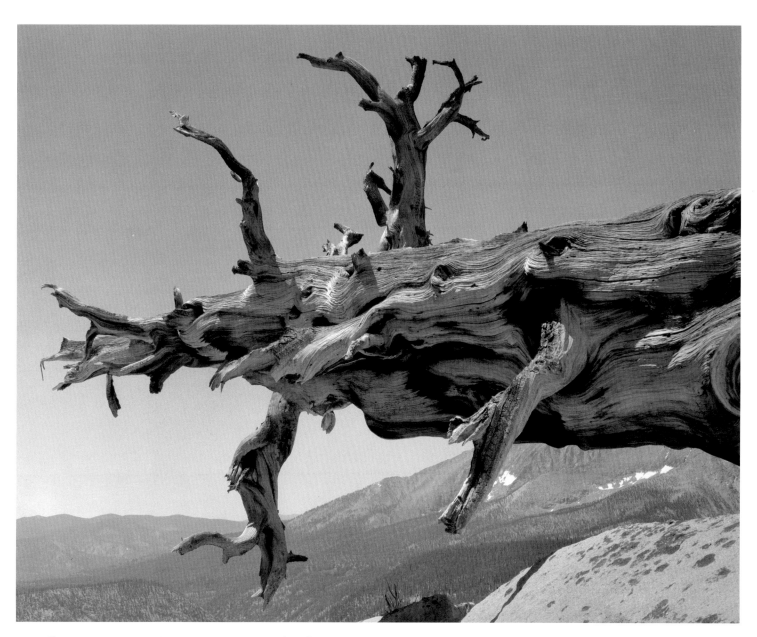

62. *Fallen Tree, Kern River Canyon, Sequoia National Park c.1936*

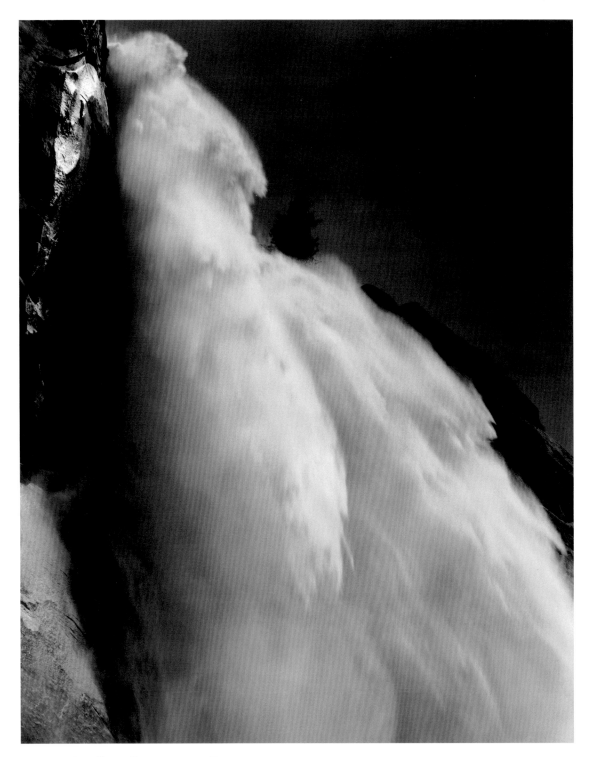

63. *Nevada Fall, Profile, Yosemite Valley c.1957*

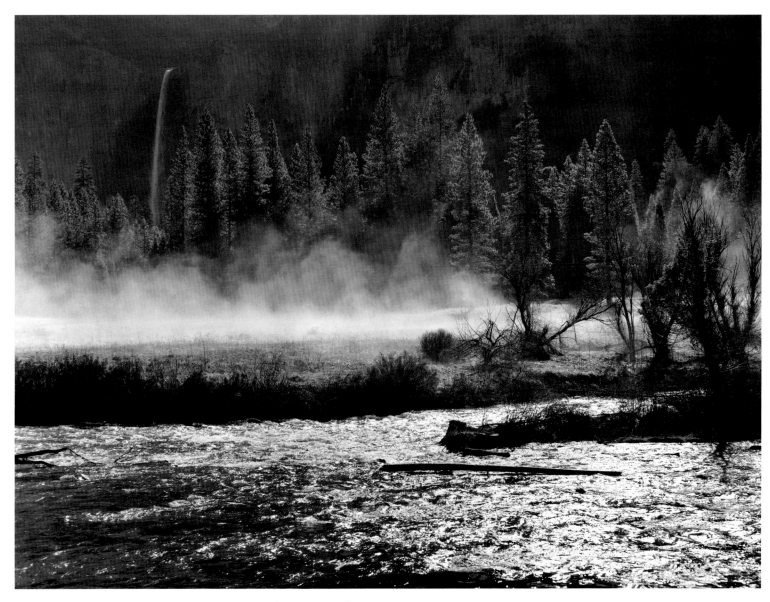

64. *Morning Mist, Merced River and Bridal Veil Fall, Yosemite Valley c.1945*

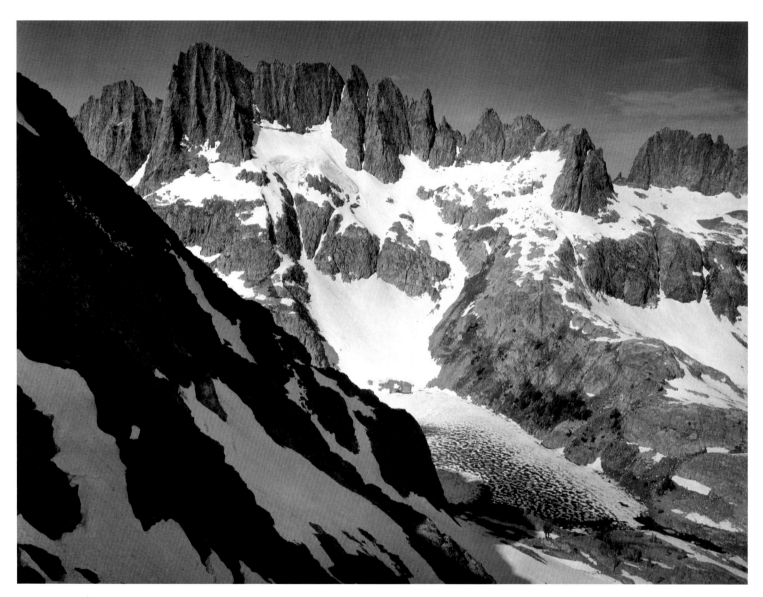

65. *The Minarets and Iceberg Lake from Volcanic Ridge, Sierra Nevada c.1935*

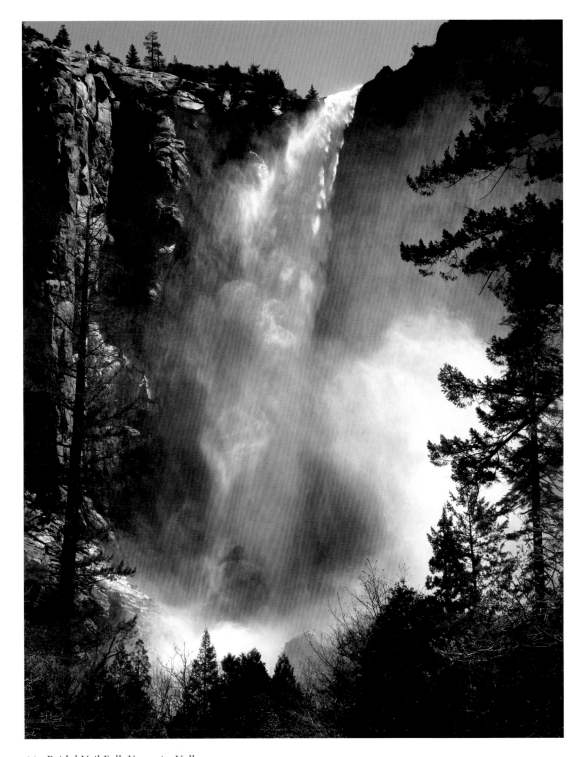

66. *Bridal Veil Fall, Yosemite Valley c.1927*

67. *Rock Veins, Tenaya Lake, Yosemite National Park c.1935*

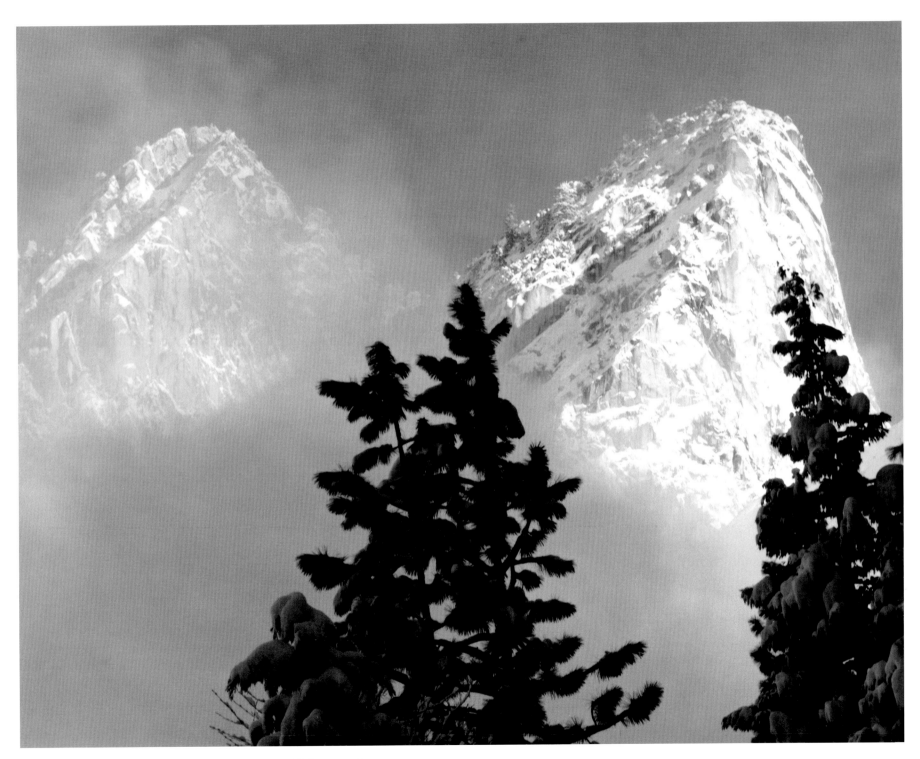

68. *Eagle Peak and Middle Brother, Winter, Yosemite Valley c.1968*

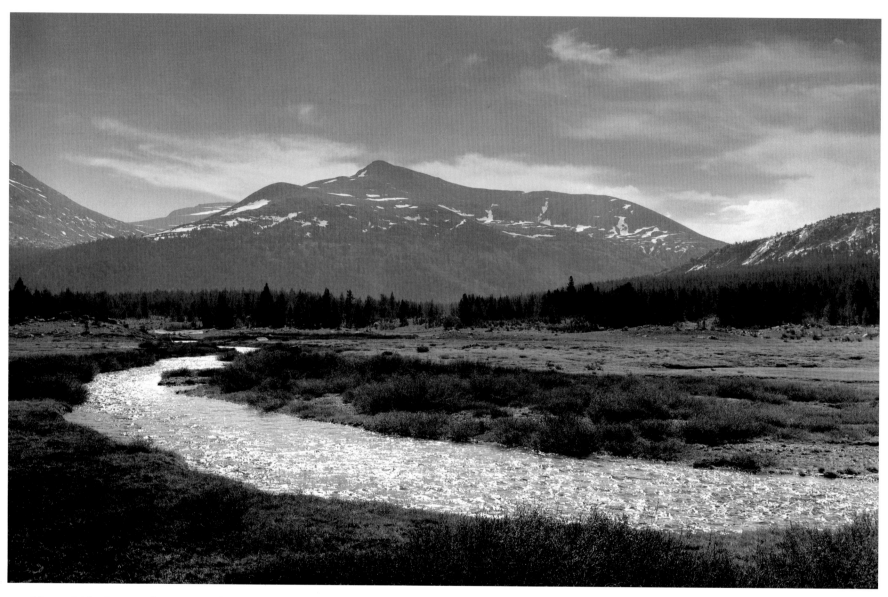

69. *Mount Gibbs, Dana Fork, Upper Tuolumne Meadows, Yosemite National Park c.1946*

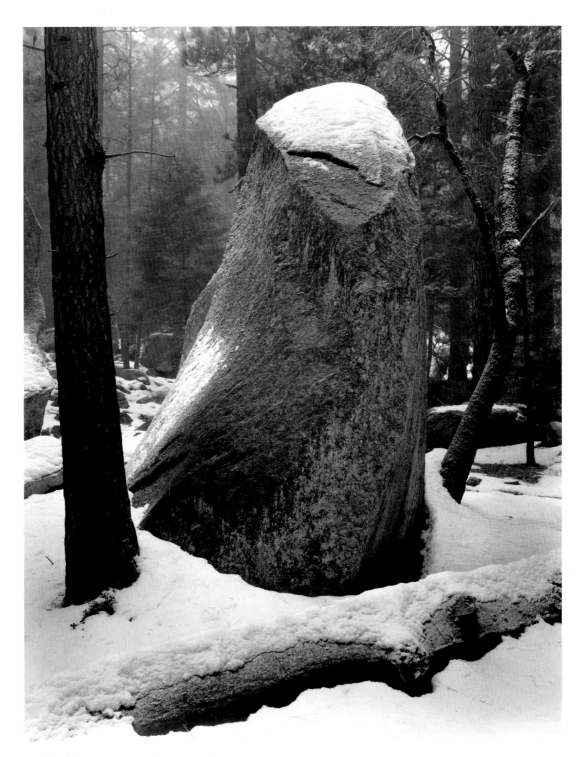

70. *Rock, Trees, Snow, Yosemite Valley c.1955*

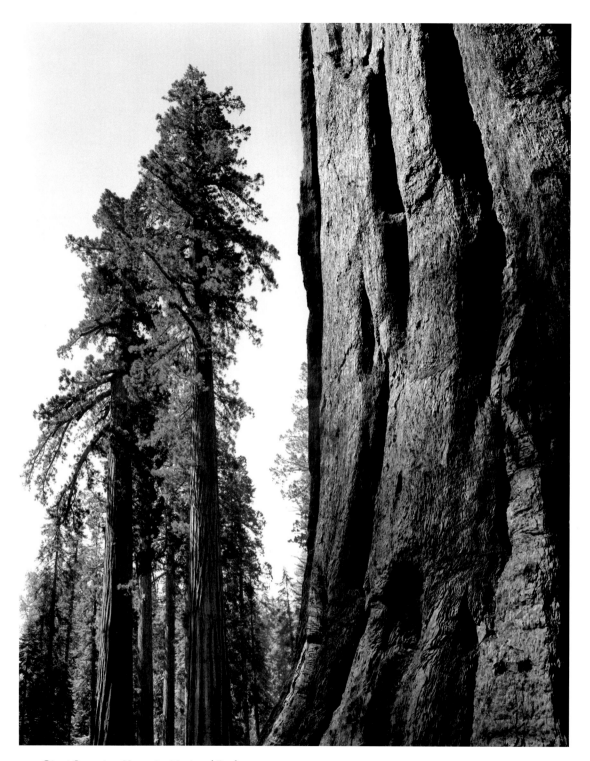

71. *Giant Sequoias, Yosemite National Park c.1944*

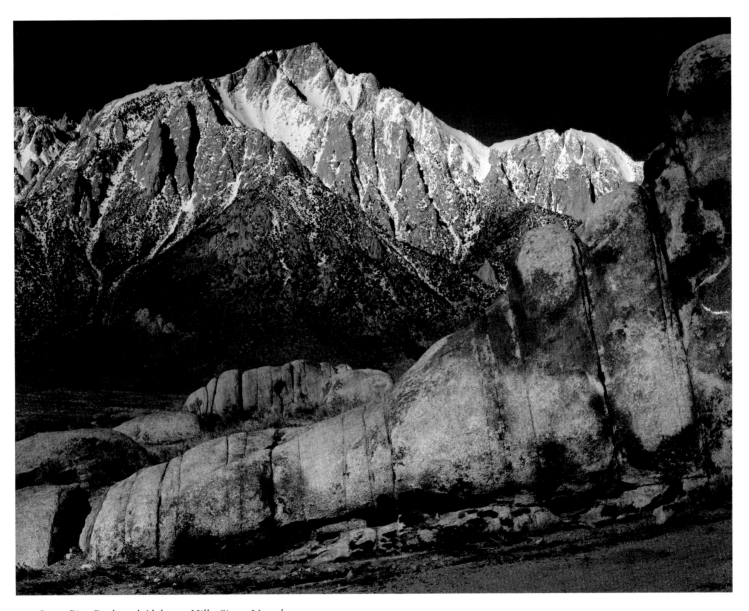

72. *Lone Pine Peak and Alabama Hills, Sierra Nevada 1949*

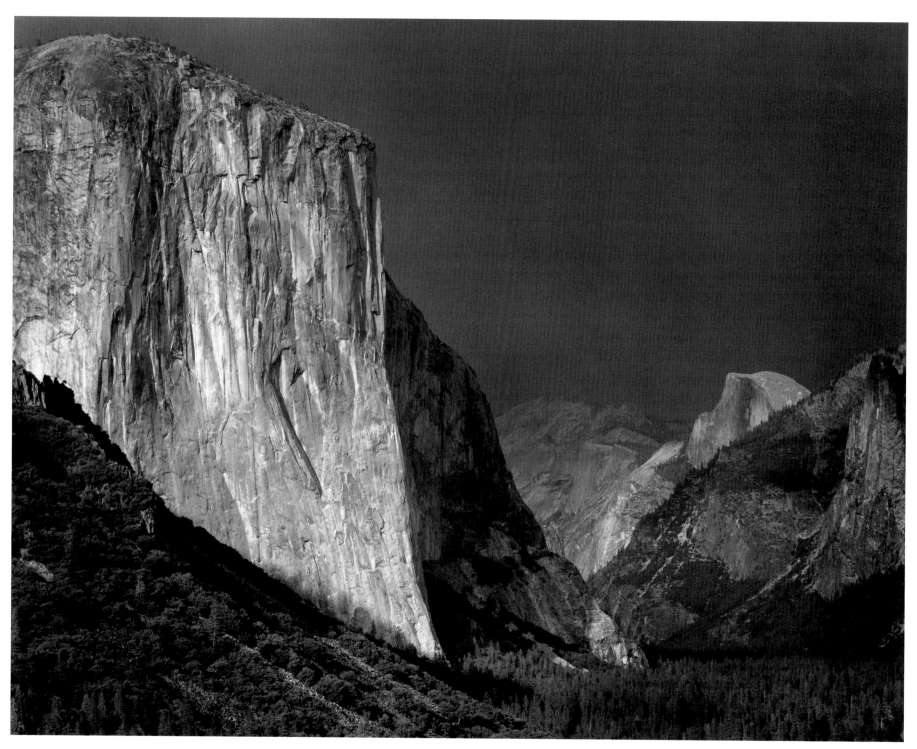

73. *El Capitan, Half Dome, Clearing Thunderstorm, Yosemite Valley c.1972*

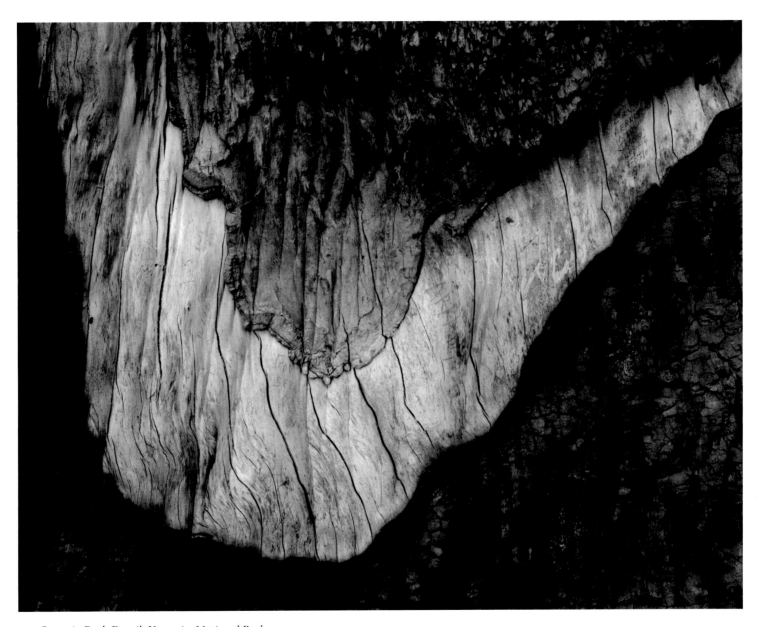

74. *Sequoia Bark Detail, Yosemite National Park c. 1954*

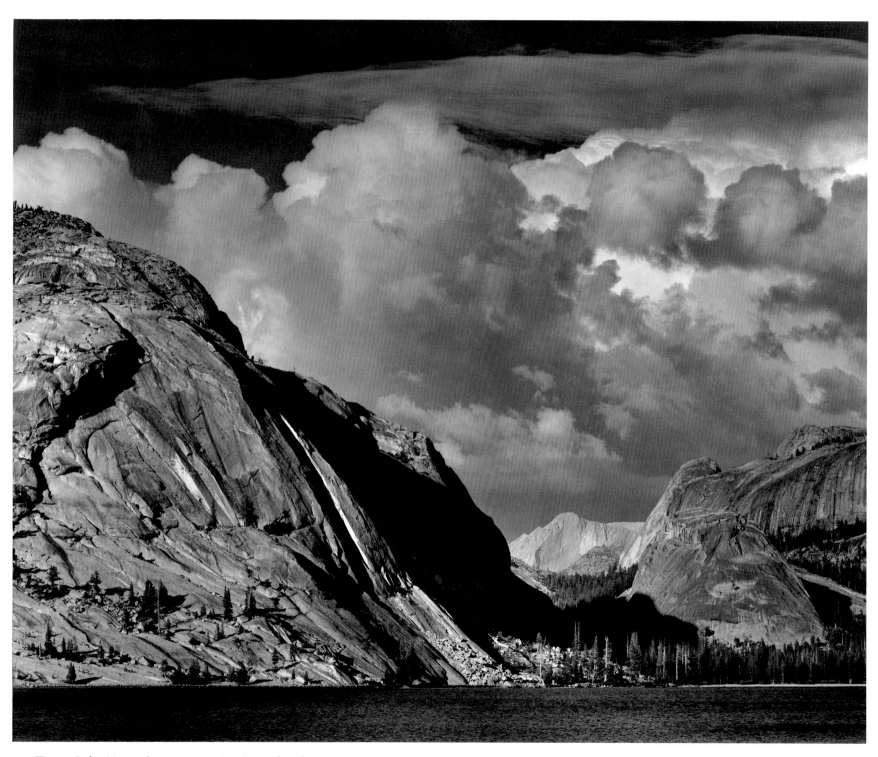

75. *Tenaya Lake, Mount Conness, Yosemite National Park* c.1946

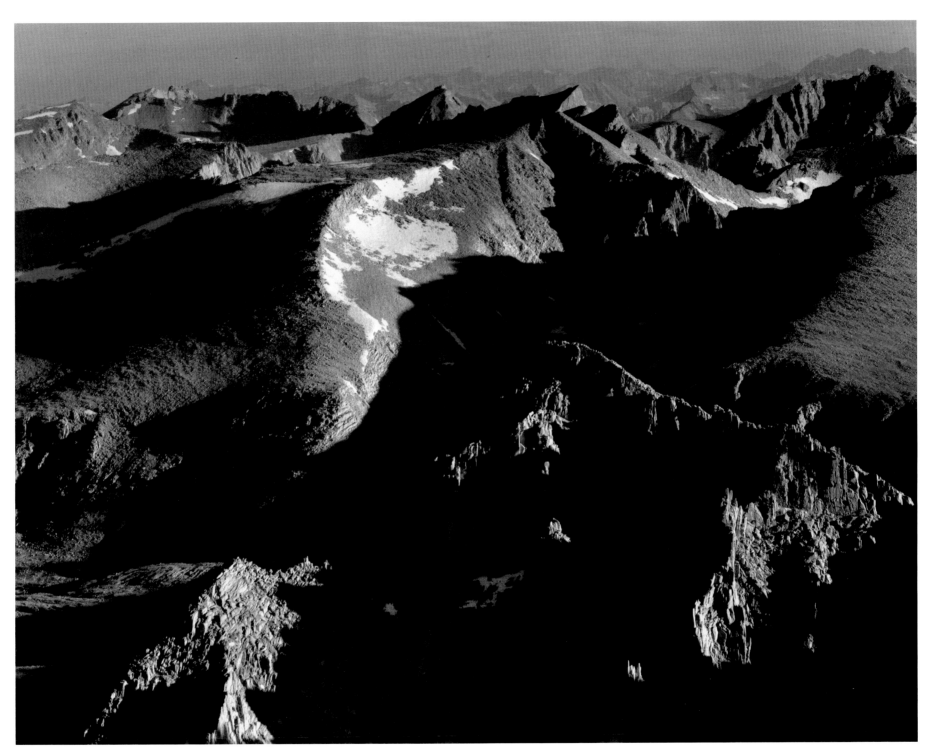

76. *Sunrise from Mount Whitney, Sequoia National Park c.1936*

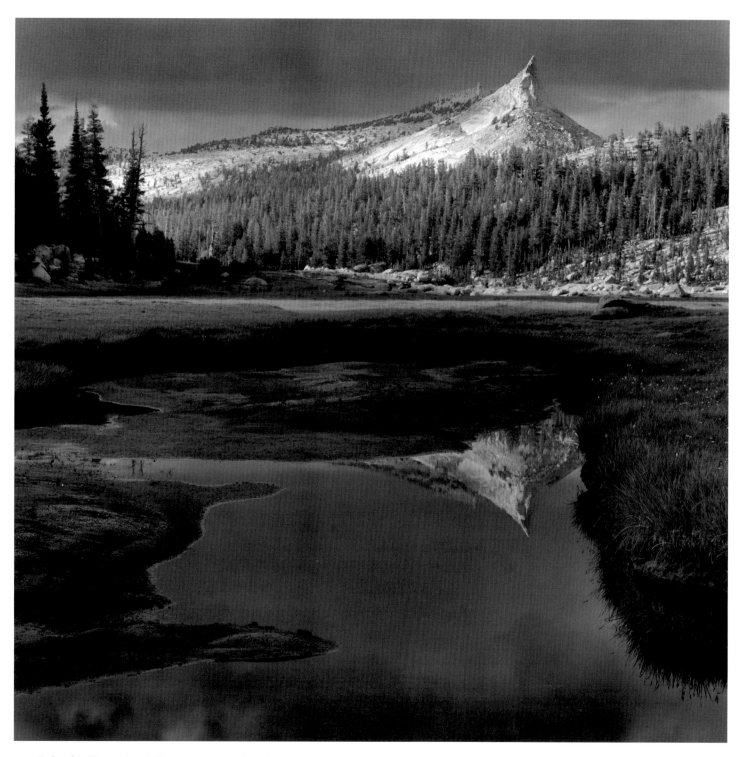

77. *Columbia Finger, Pool, Yosemite National Park c. 1960*

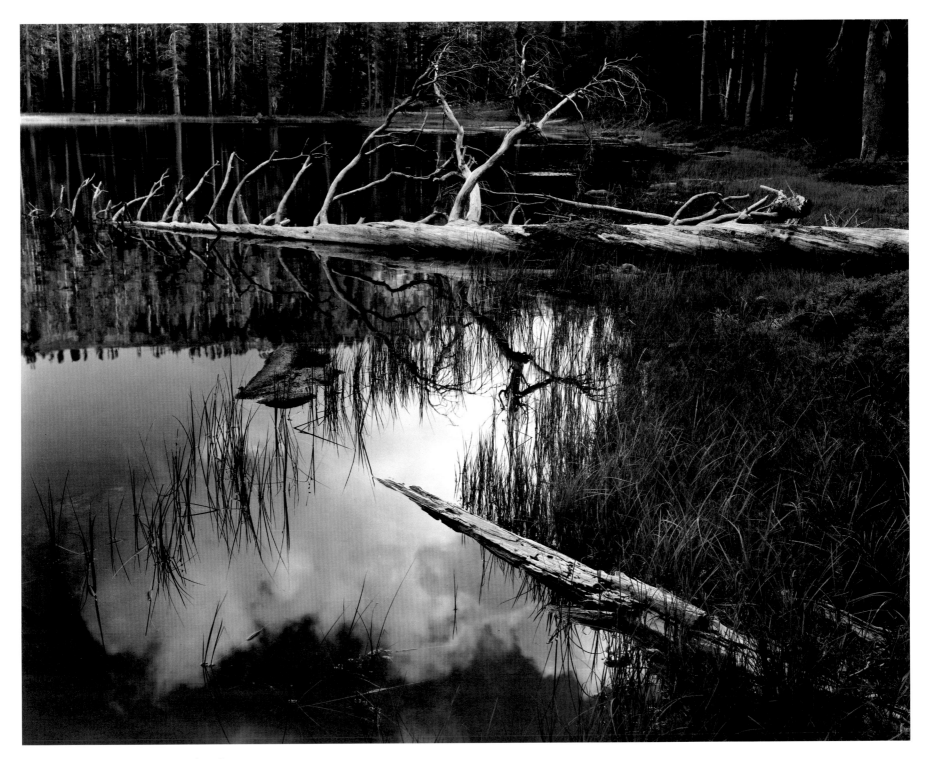

78. *Siesta Lake, Yosemite National Park c.1958*

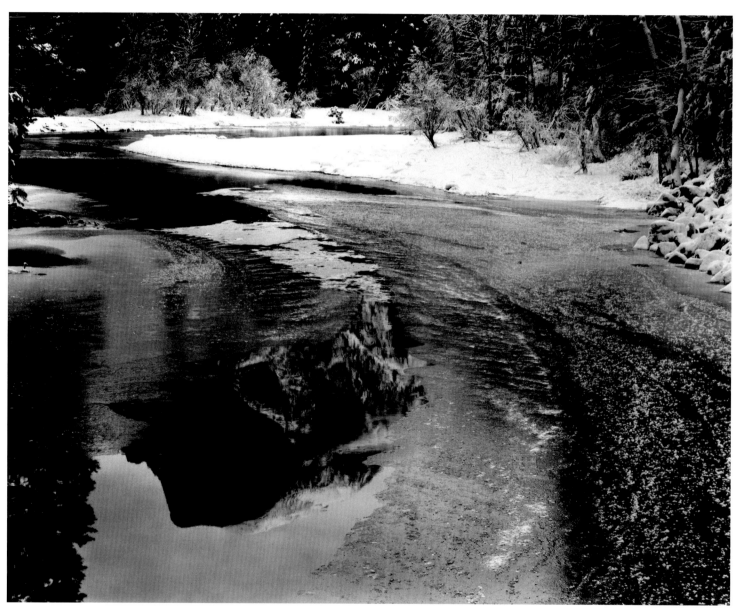

79. *Half Dome, Reflections, Merced River, Winter, Yosemite Valley c.1945*

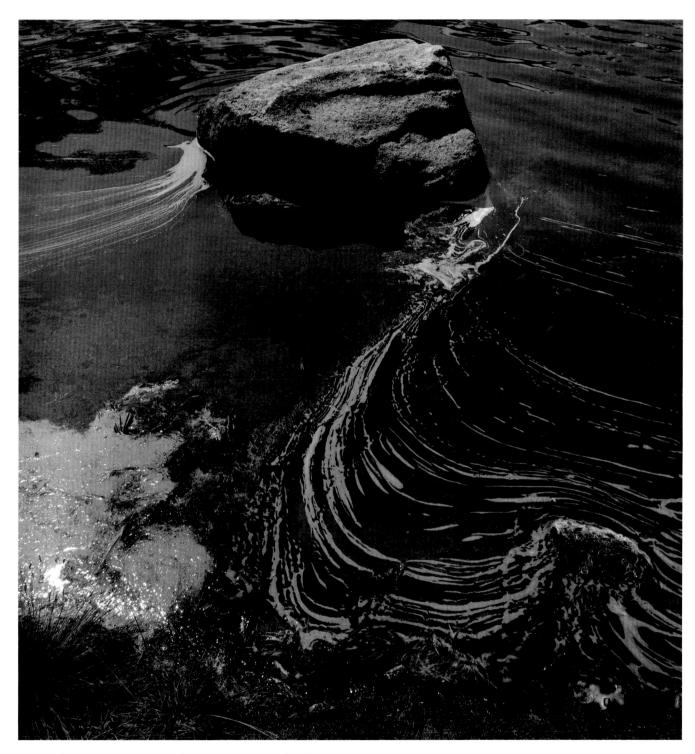

80. Rock and Foam, Tenaya Lake, Yosemite National Park c.1960

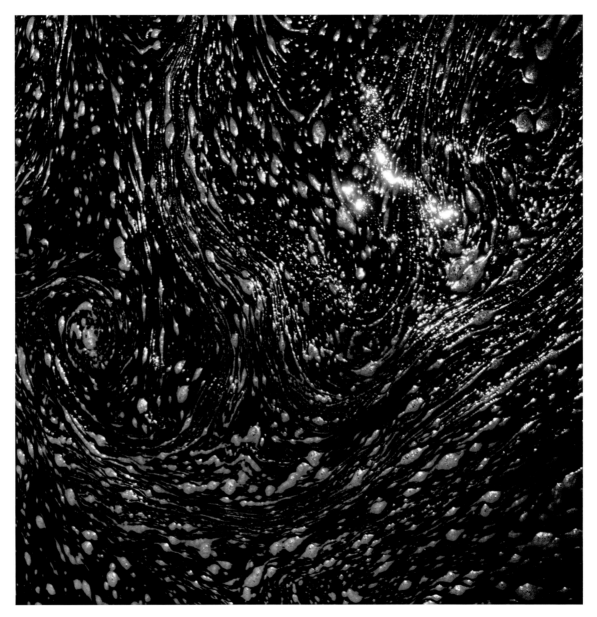

81. *Foam, Mirror Lake, Yosemite Valley c.1960*

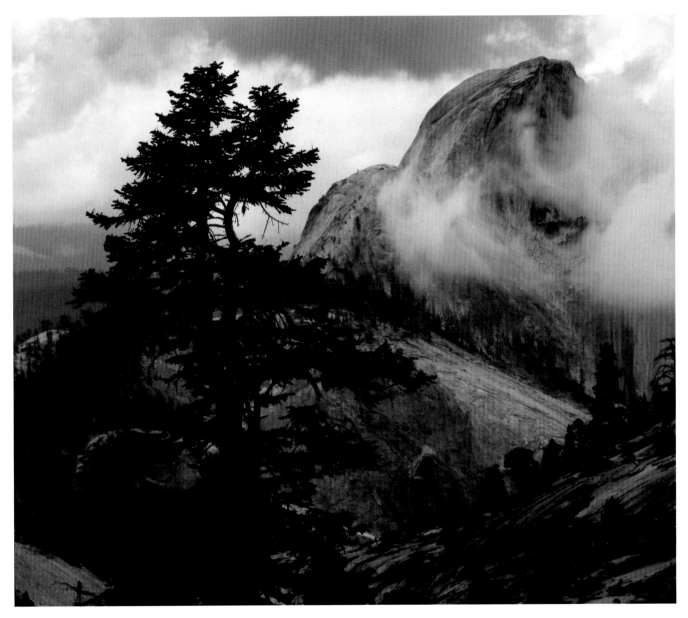

82. *Half Dome, Tree, Clouds, from Olmsted Point, Yosemite Valley c.1970*

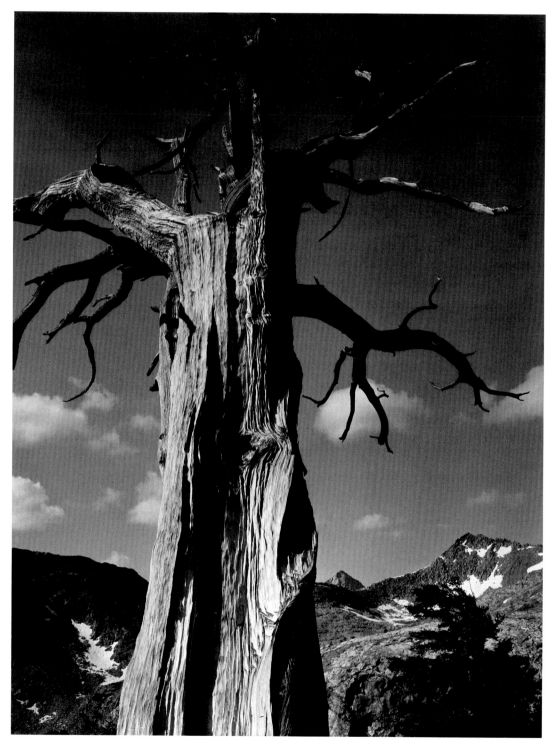

83. *Dead Tree near Little Five Lakes, Sequoia National Park c.1932*

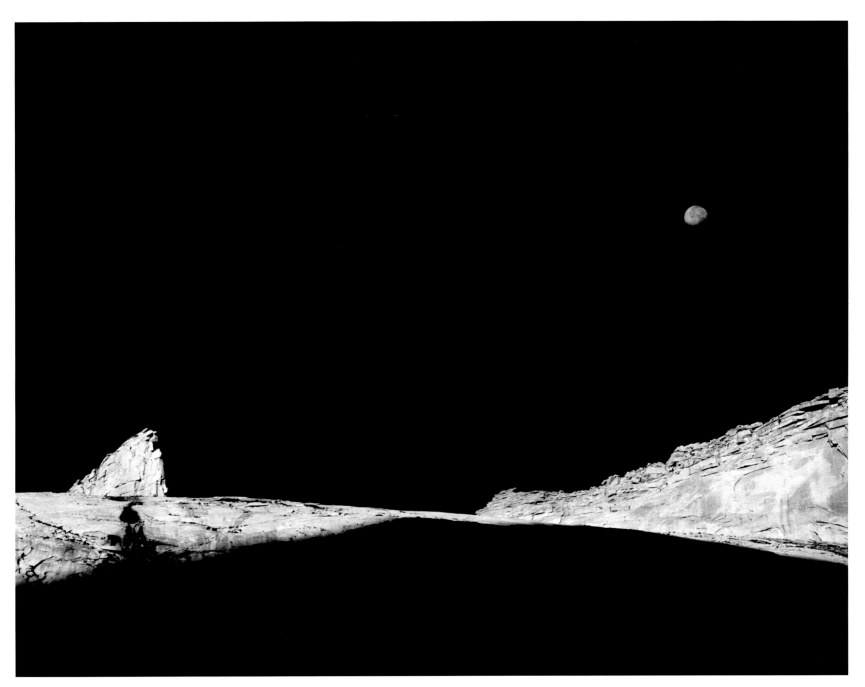

84. *High Country Crags and Moon, Sunrise, Kings Canyon National Park c.1935*

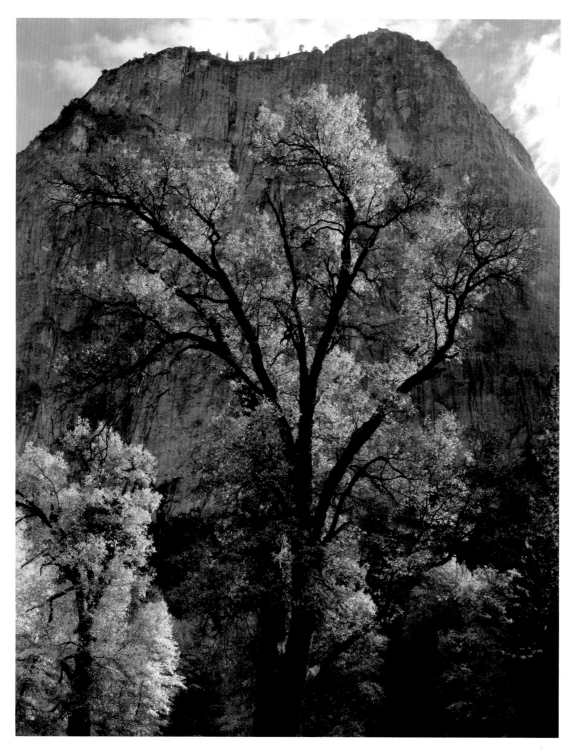

85. *Autumn Tree against Cathedral Rocks, Yosemite Valley c.1944*

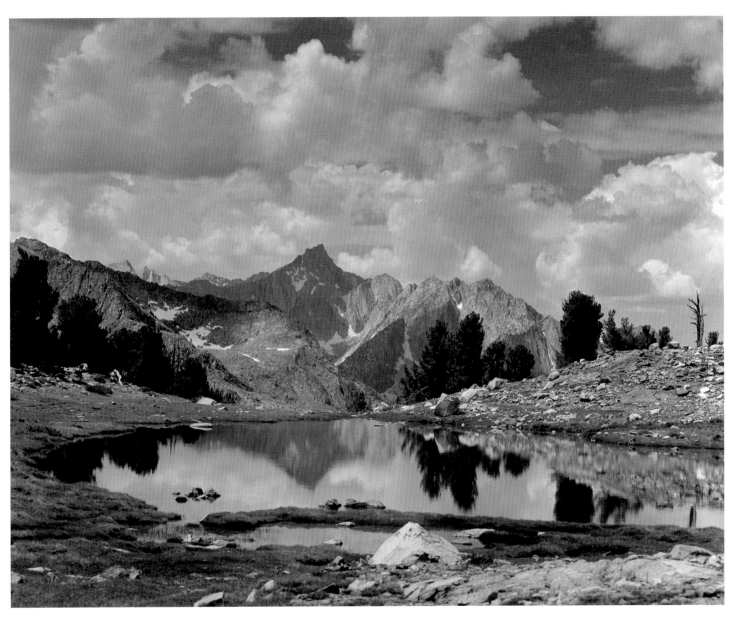

86. *Mount Clarence King, Pool, Kings Canyon National Park c.1925*

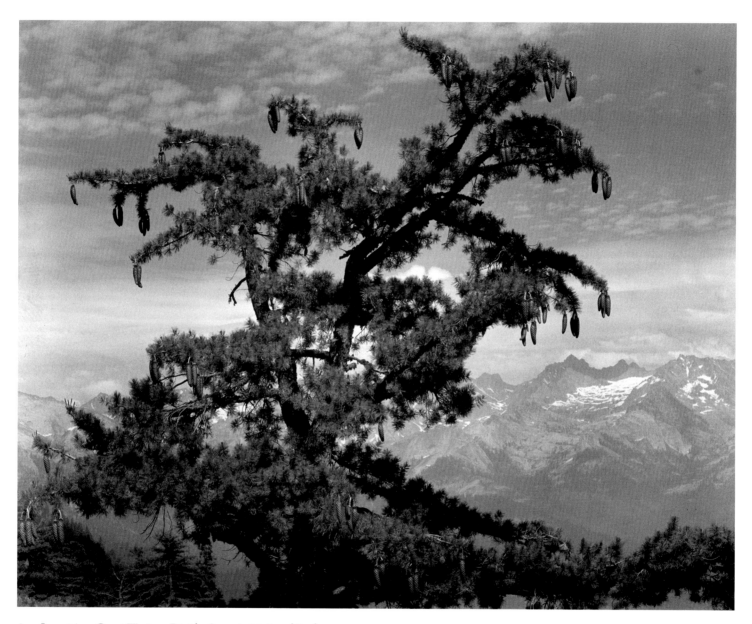

87. *Sugarpine, Great Western Divide, Sequoia National Park* c.1925

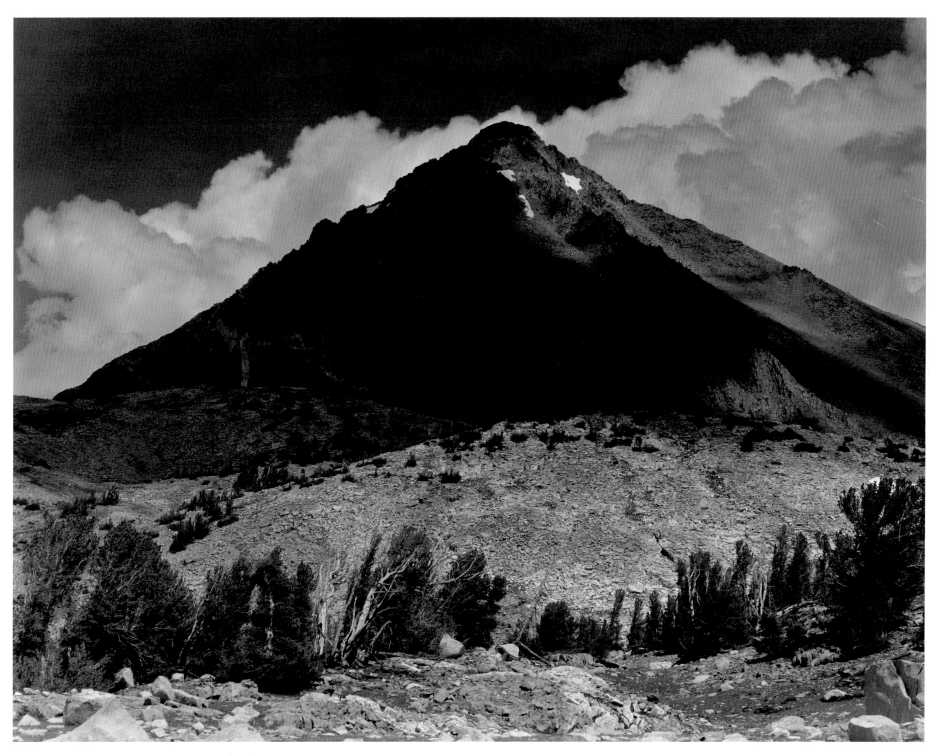

88. *Mount Wynne, Kings Canyon National Park c.1933*

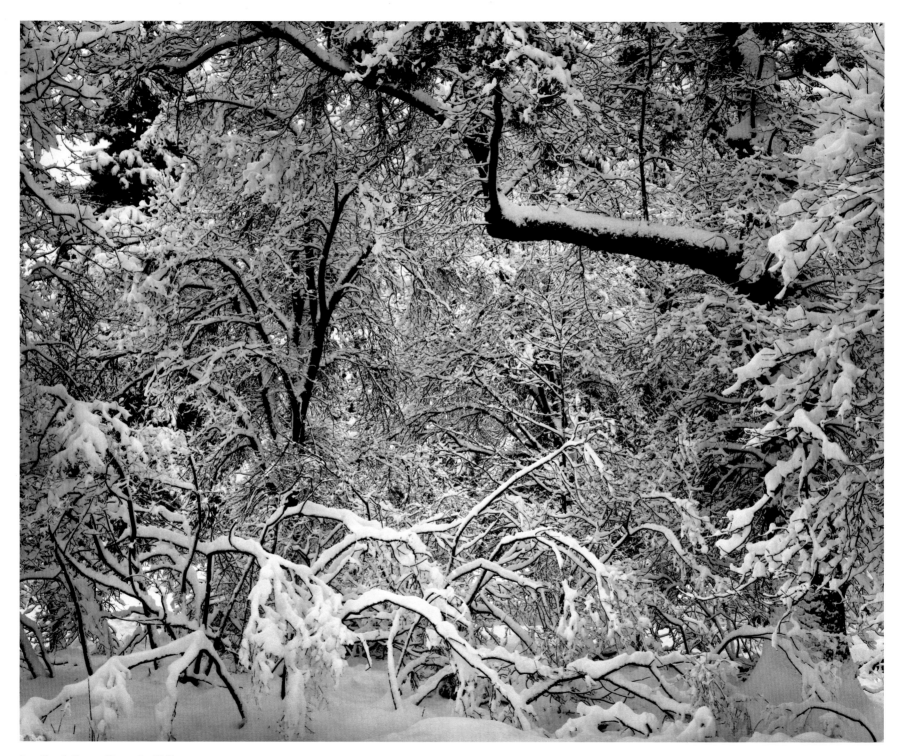

89. *Fresh Snow, Yosemite Valley c.1947*

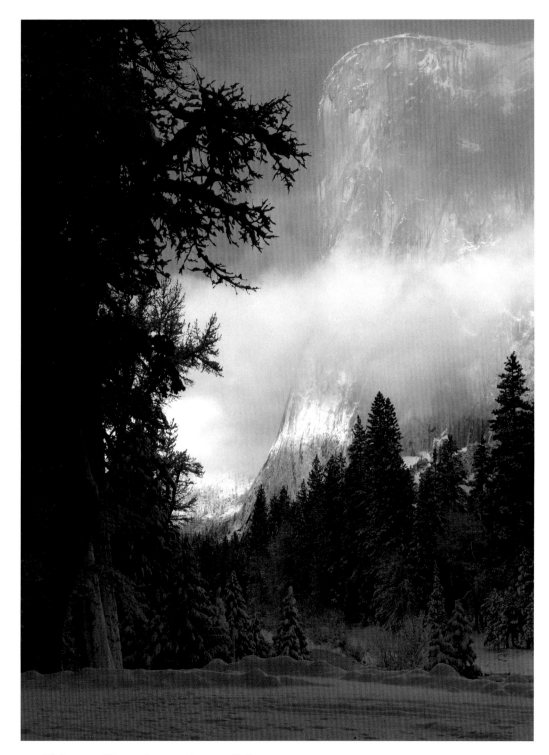

90. *El Capitan, Winter, Sunrise, Yosemite Valley c.1968*

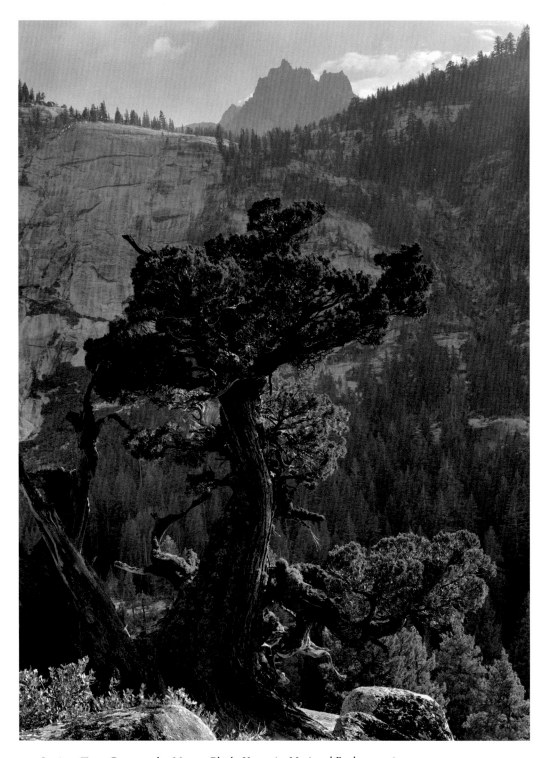

91. *Juniper Tree, Crags under Mount Clark, Yosemite National Park c.1936*

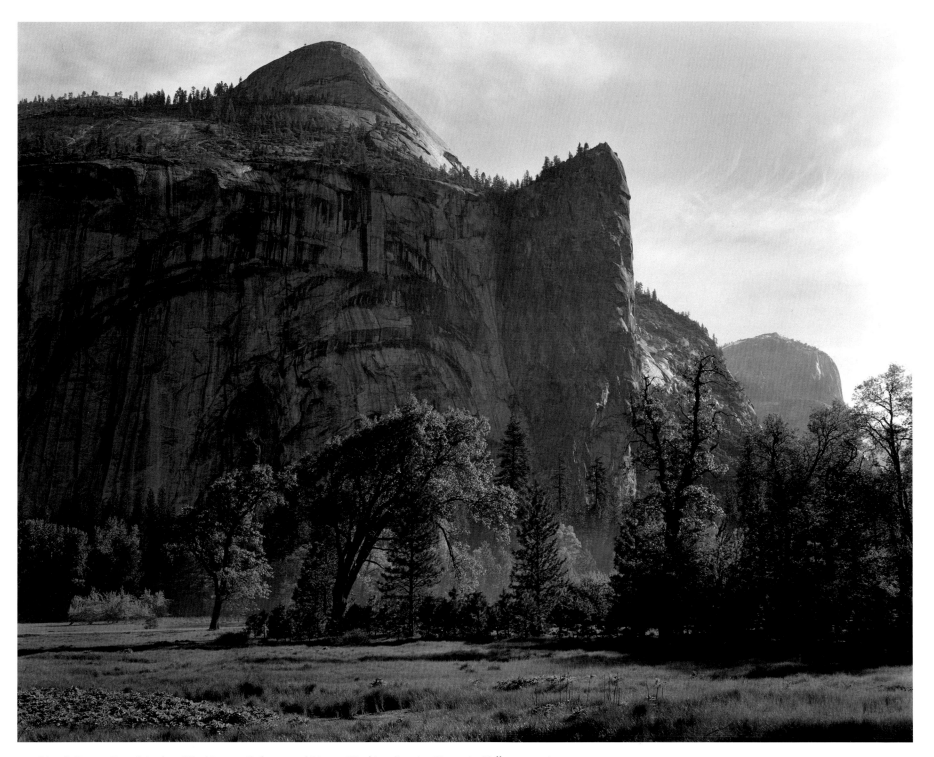

92. *North Dome, Royal Arches, Washington Column and Mount Watkins, Sunrise, Yosemite Valley c. 1936*

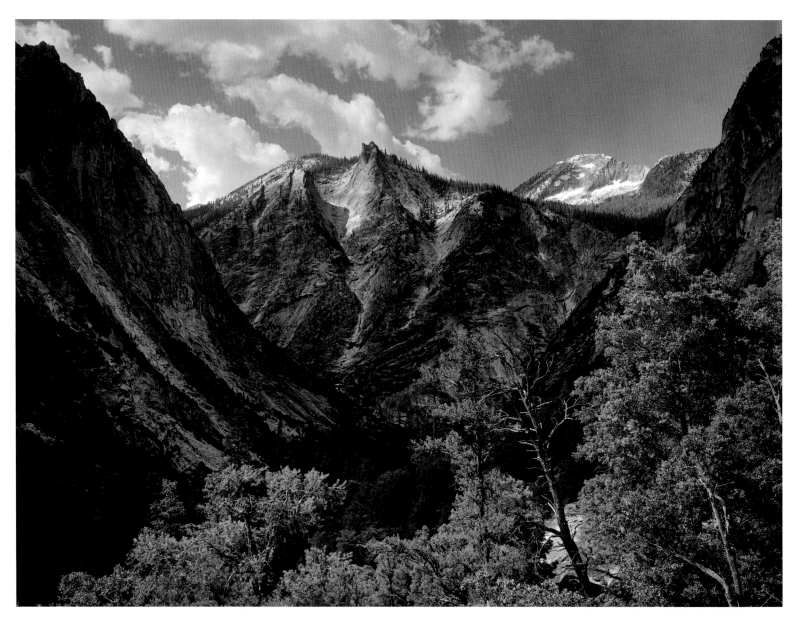

93. *In Paradise Valley, Kings Canyon National Park c.1925*

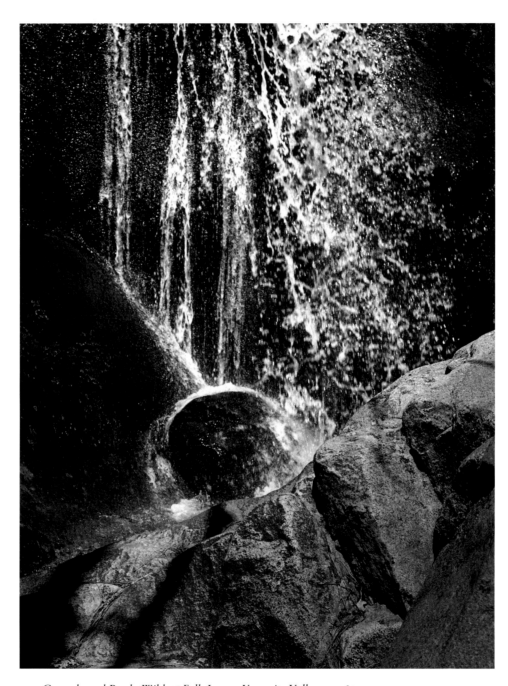

94. *Cascade and Rock, Wildcat Fall, Lower Yosemite Valley c.1960*

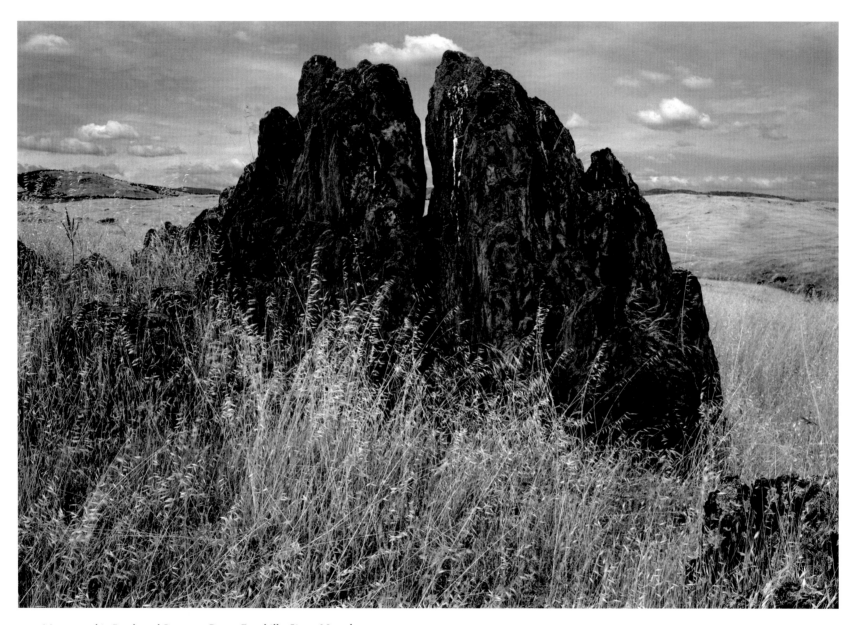

95. *Metamorphic Rock and Summer Grass, Foothills, Sierra Nevada 1945*

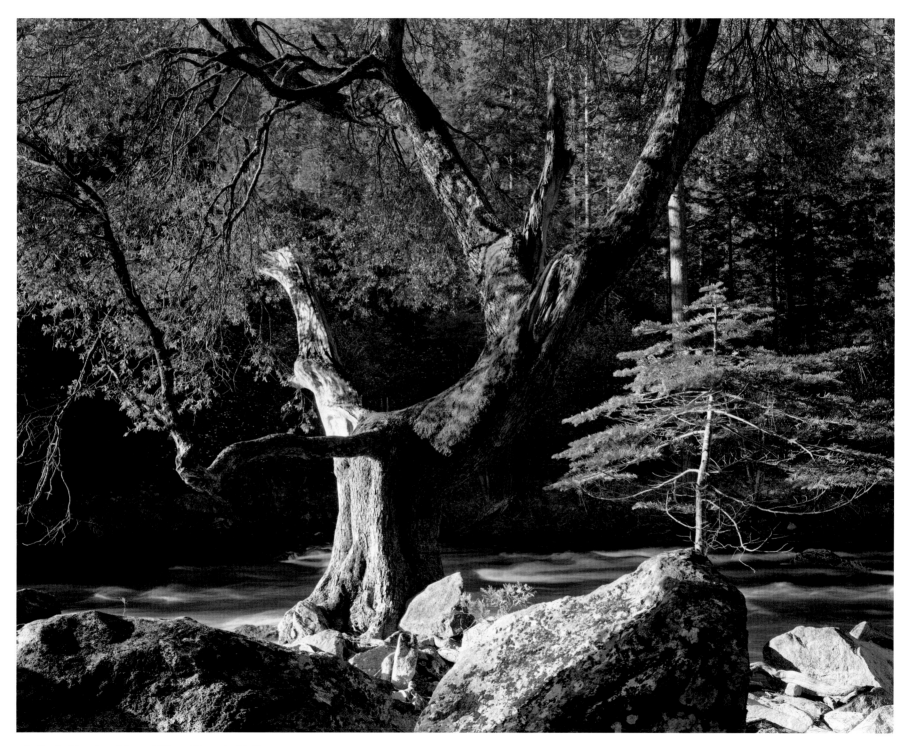

96. *Early Morning, Merced River, Yosemite Valley c.1950*

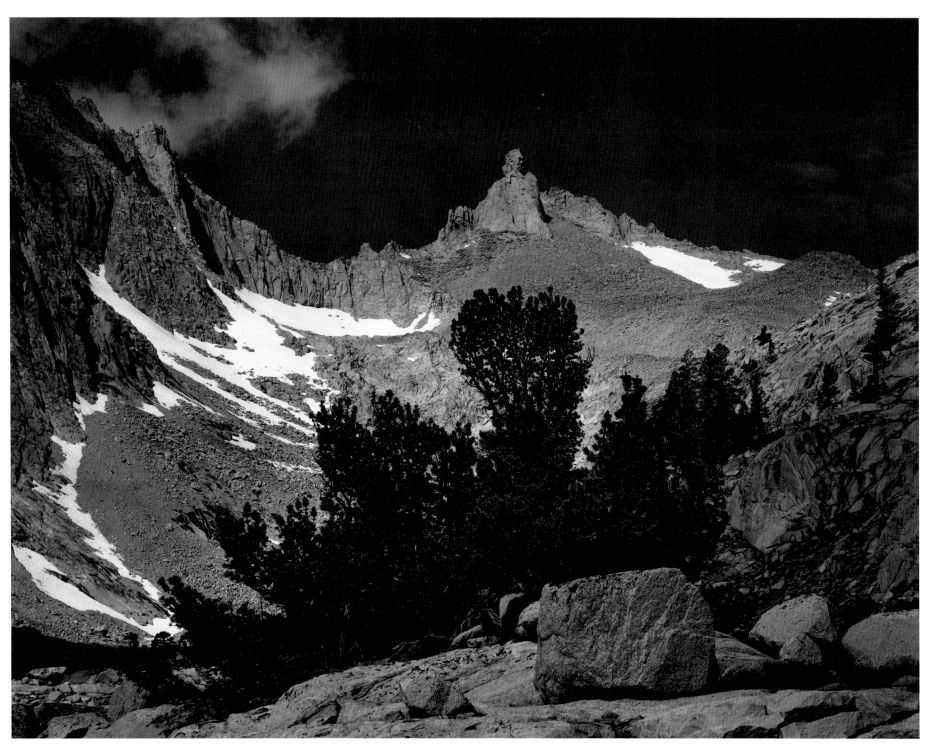

97. *Milestone Mountain, Sequoia National Park c.1936*

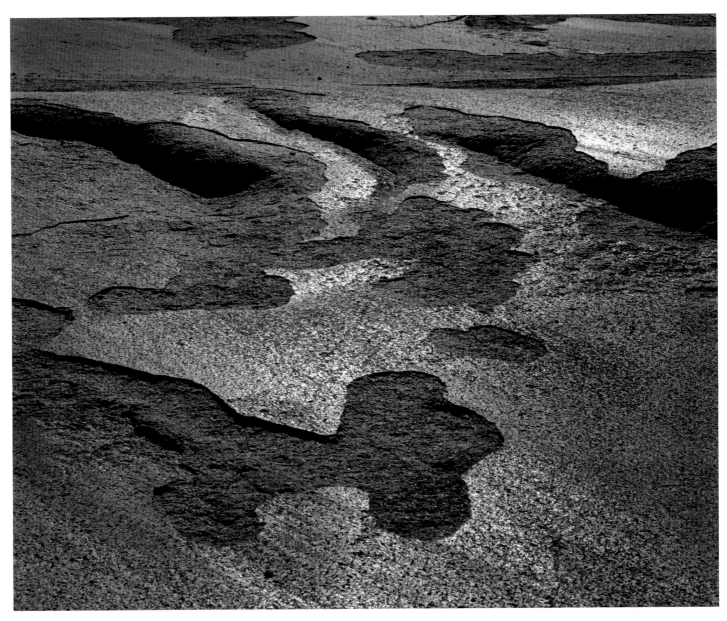

98. *Glacier Polish, Tenaya Lake, Yosemite National Park c.1960*

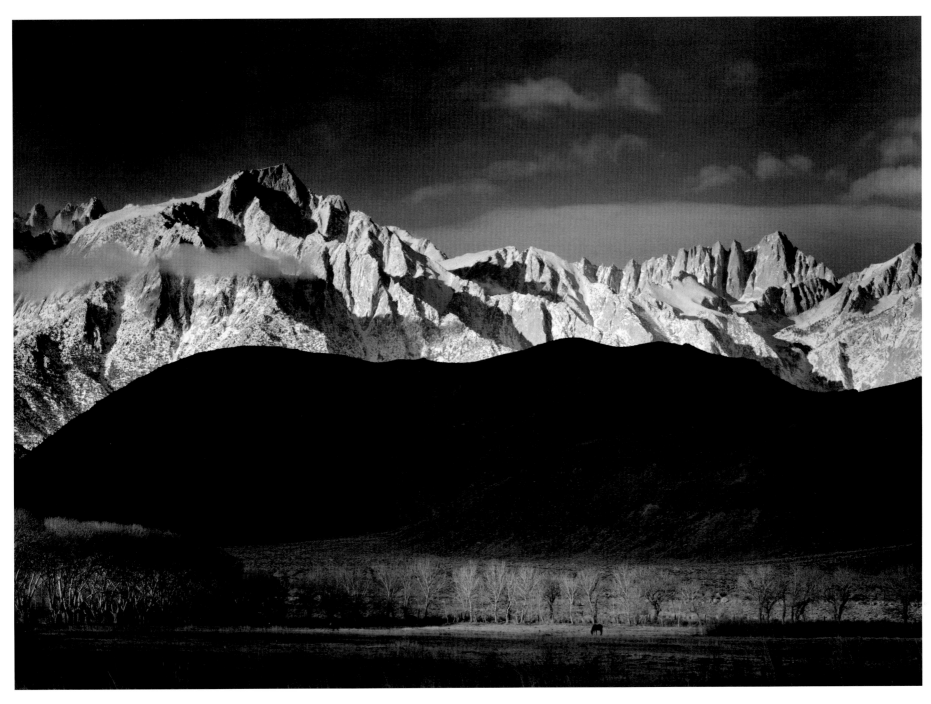

99. *Winter Sunrise, Sierra Nevada, from Lone Pine 1944*

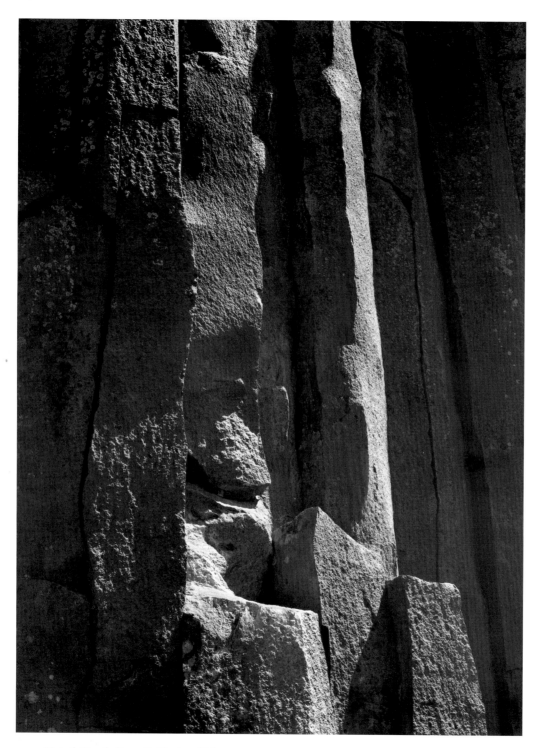

100. Detail, Devils Postpile National Monument 1946

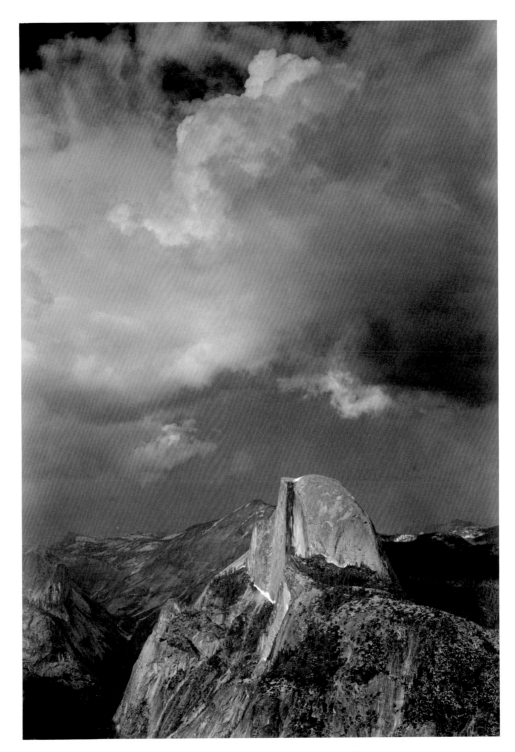

101. *Half Dome, Thunderclouds, from Glacier Point, Yosemite Valley 1947*

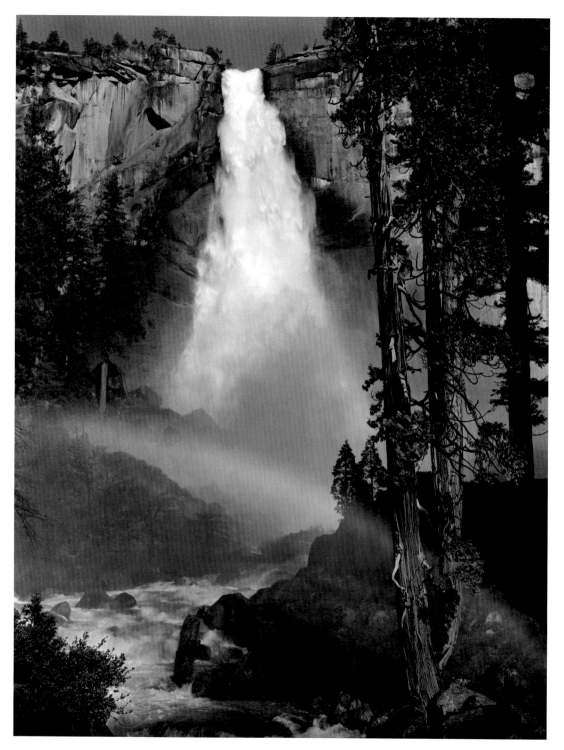

102. *Nevada Fall, Rainbow, Yosemite Valley* c. 1947

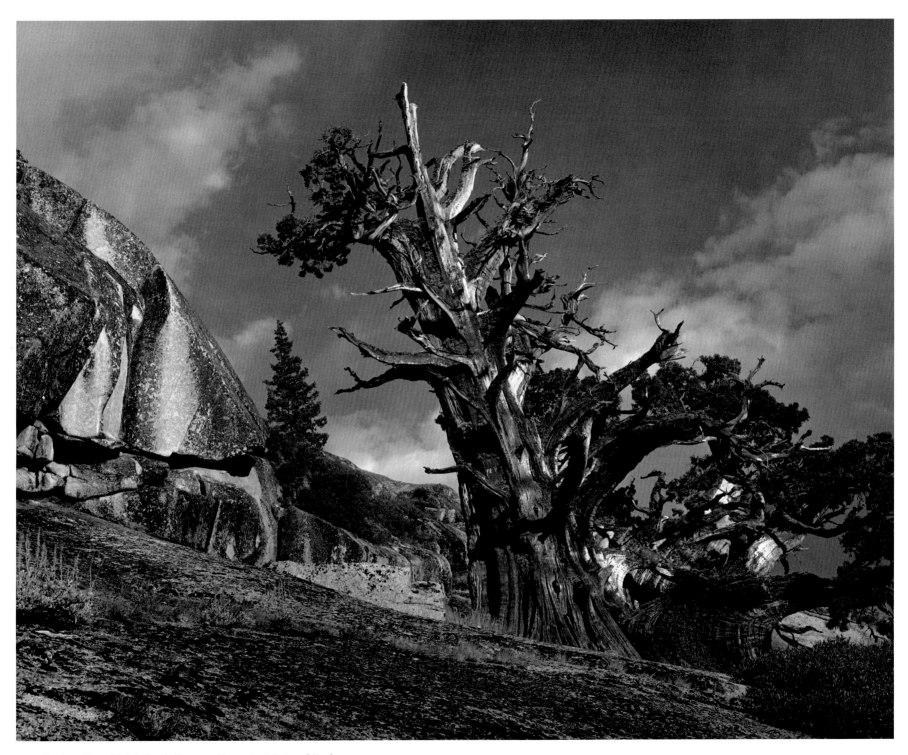

103. *Juniper Tree, Triple Peak Canyon, Yosemite National Park c.1940*

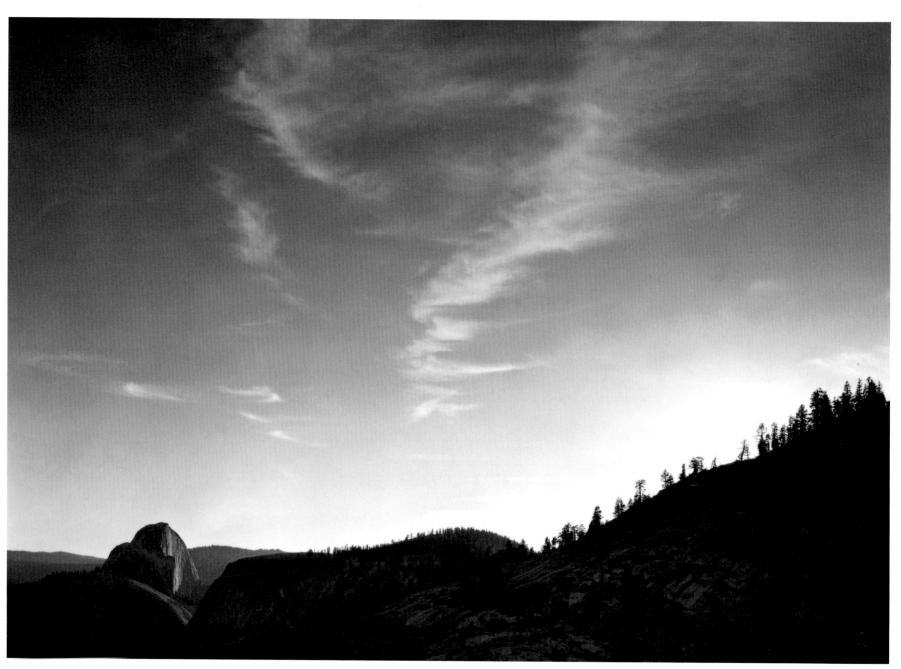

104. *Half Dome, Evening, from Olmsted Point, Yosemite National Park c.1959*

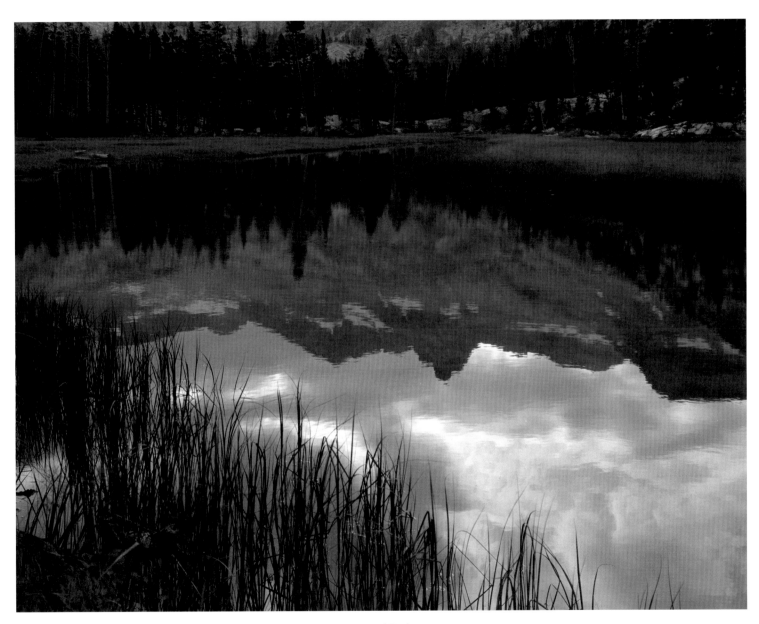

105. *Grass, Reflections, Lyell Fork of the Merced River, Yosemite National Park c. 1943*

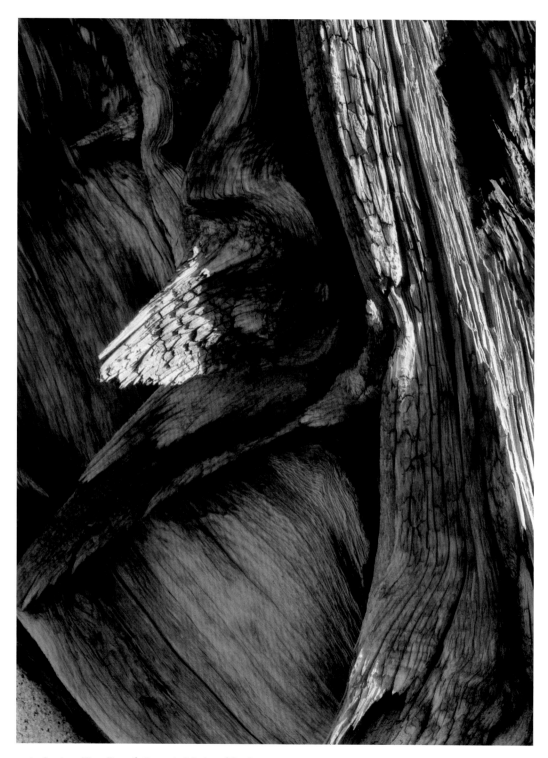

106. *Juniper Tree Detail, Sequoia National Park c.1927*

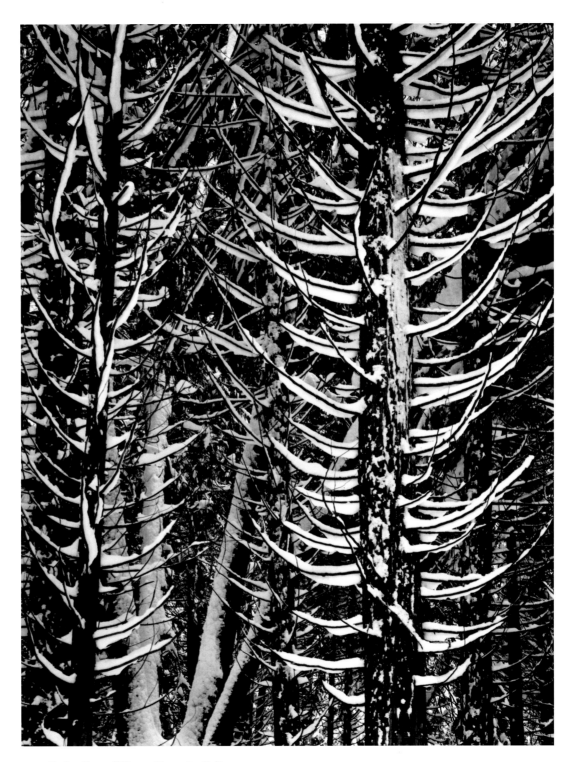

107. *Cedar Trees, Winter, Yosemite Valley c.1949*

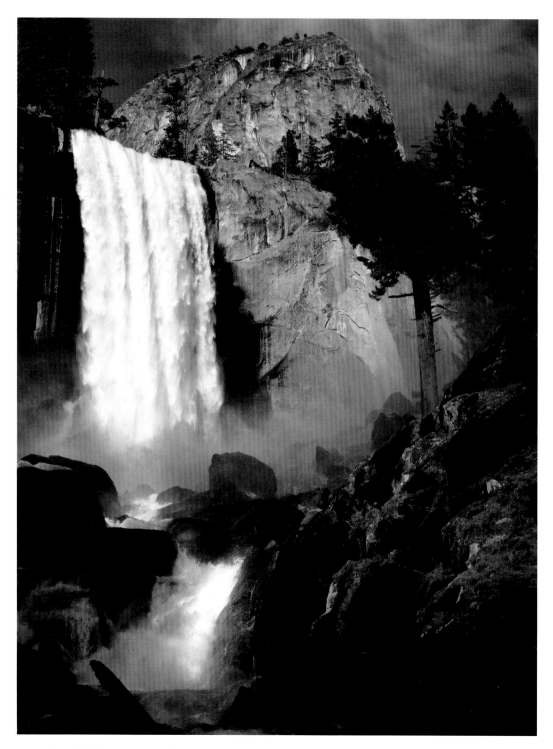

108. Vernal Fall, Yosemite Valley c.1948

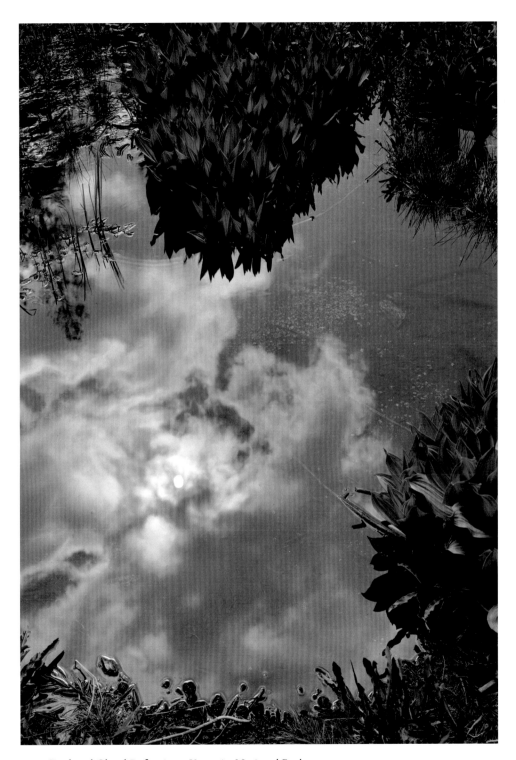

109. *Pool and Cloud Reflections, Yosemite National Park* c.1945

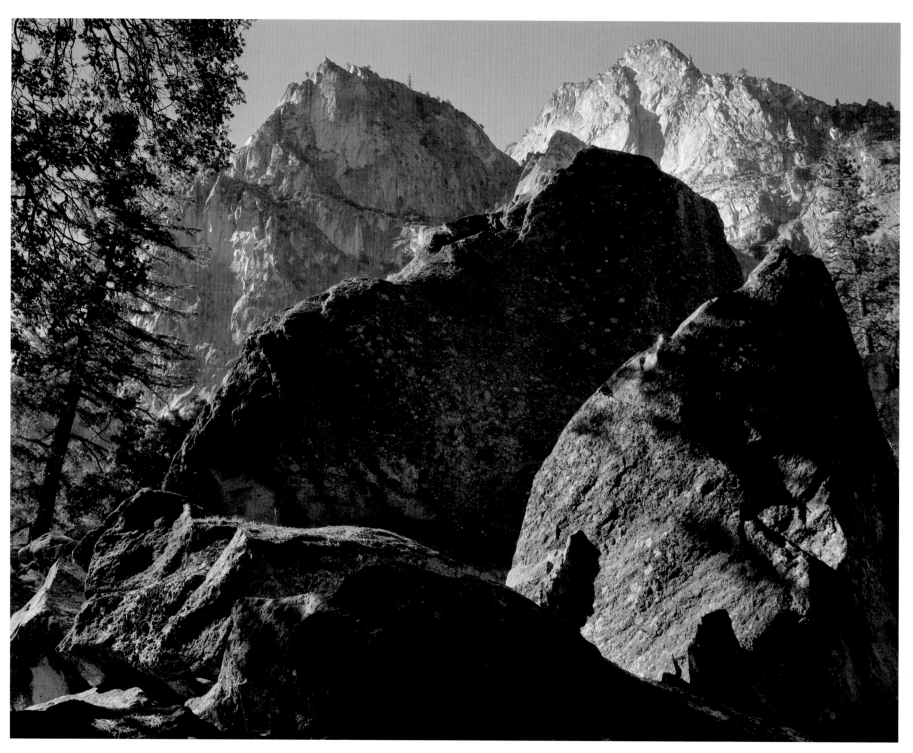

110. *Grand Sentinel and Talus, Kings Canyon National Park c.1925*

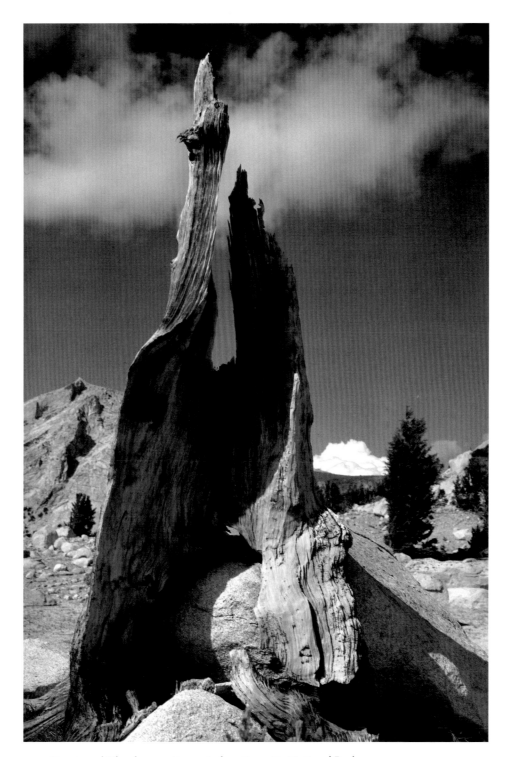

III. Stump and Clouds, near Young Lakes, Yosemite National Park c.1945

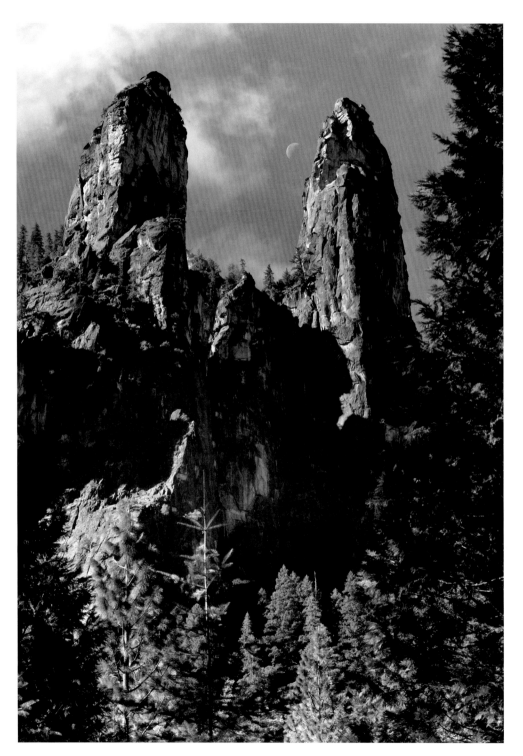

112. *Cathedral Spires and Moon, Yosemite Valley c.1949*

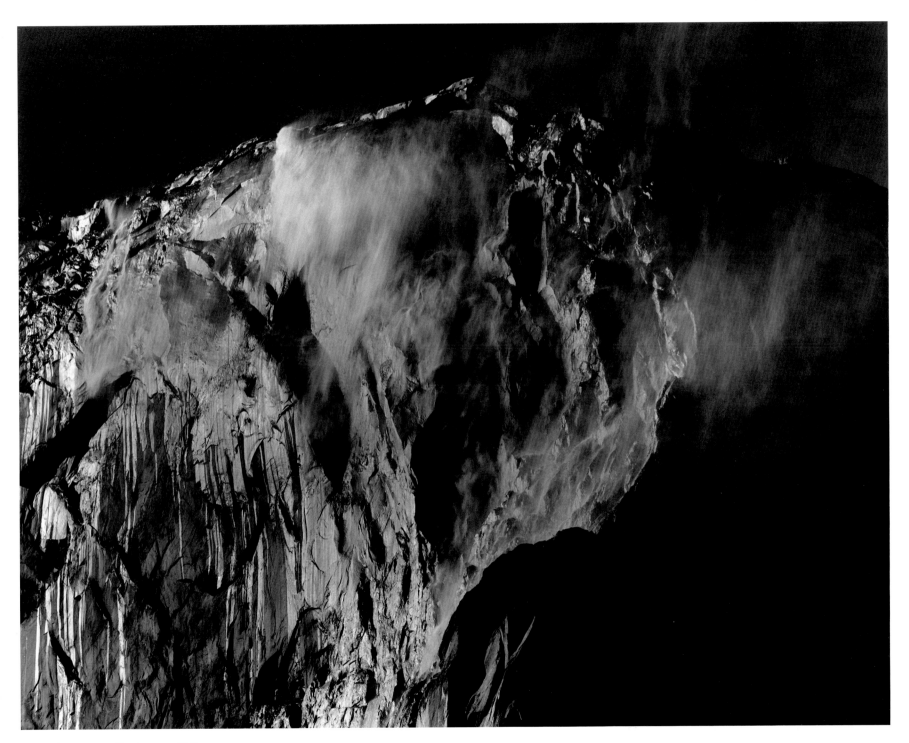

113. *El Capitan Fall, Yosemite Valley c.1940*

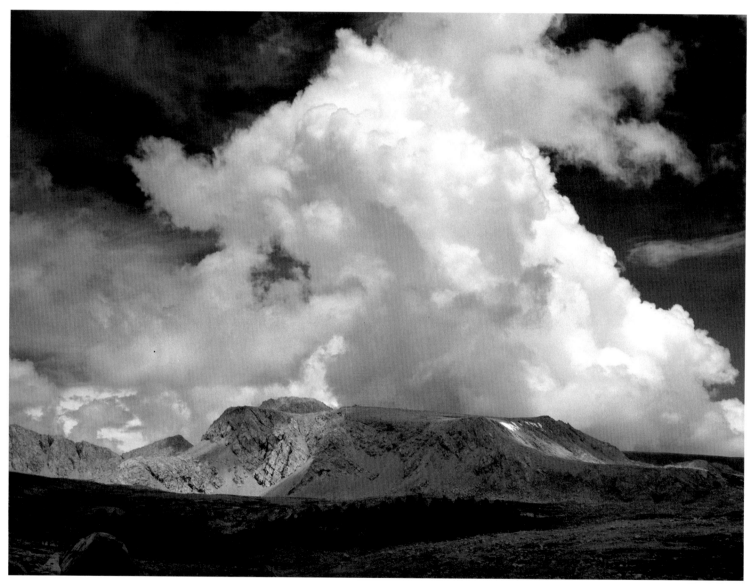

114. *Afternoon Clouds near the Kings-Kern Divide, Sequoia National Park c.1936*

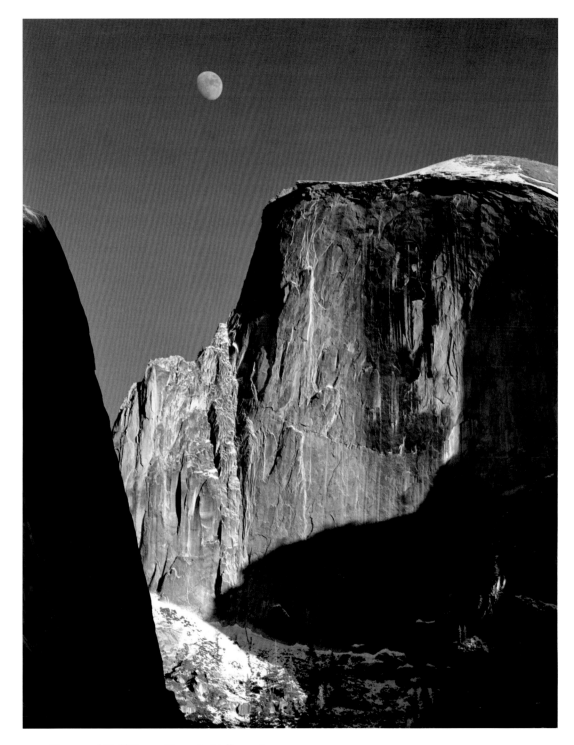

115. Moon and Half Dome, Yosemite Valley 1960

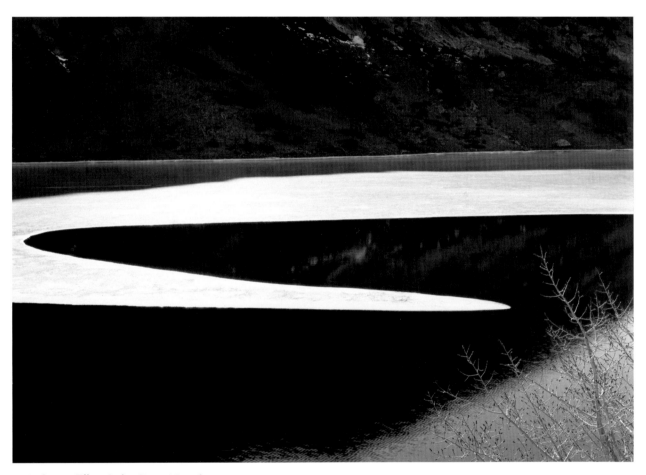

116. Ice on Ellery Lake, Sierra Nevada c.1959

List of Photographs

All photographs were taken in the Sierra Nevada, the principal mountain range in California. Those photographs of scenes in national parks or monuments are so designated; those not otherwise assigned are simply labeled Sierra Nevada. Photographs of Yosemite National Park are further differentiated by specifying those taken in Yosemite Valley.

Acknowledgments

I salute the many friends and associates who—over a span of more than fifty years—have helped me so generously in my pursuit of photography.

Specifically, I must thank Lance Hidy, who assisted in the selection of and also magnificently sequenced this complex group of images. And I must thank Andrea Turnage, who helped with the selection and then followed through on all stages of the book's production. My appreciation to Alan Ross, my photographic assistant, and to Phyllis Donohue and Marc Gaede, who were most helpful in preparing and identifying proofs and prints for reproduction. And, as always, my gratitude to my understanding editor, Tim Hill, and my very cooperative publisher, New York Graphic Society, as well as their outstanding staff. And, finally, my deep thanks to William Turnage, who so effectively worked out the many practical details of this project.

EDITED BY TIM HILL

PRODUCTION COORDINATED BY NAN JERNIGAN

DESIGNED BY LANCE HIDY

CALLIGRAPHY BY STEPHEN HARVARD

TYPE SET IN SABON BY ROY MCCOY, CAMBRIDGE, MASSACHUSETTS

PAPER IS QUINTESSENCE BY NORTHWEST PAPER COMPANY

PRINTED BY GARDNER LITHOGRAPH, BUENA PARK, CALIFORNIA

BOUND BY A. HOROWITZ AND SON, FAIRFIELD, NEW JERSEY